FREDERICK H. EVANS

FREDERICK H. EVANS

ERRATA

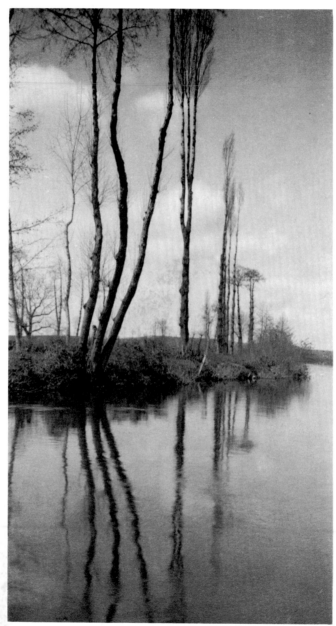

Reflets Dans L'Eau

FREDERICK H. EVANS

PHOTOGRAPHER OF THE MAJESTY, LIGHT AND SPACE OF THE MEDIEVAL CATHEDRALS OF ENGLAND AND FRANCE

BEAUMONT NEWHALL

AN APERTURE MONOGRAPH

FREDERICK H. EVANS
IS PUBLISHED TO ACCOMPANY A MAJOR EXHIBITION
OF BRITISH PHOTOGRAPHERS PRIOR TO 1915
TO BE PRESENTED BY THE ALFRED STIEGLITZ CENTER
OF THE PHILADELPHIA MUSEUM OF ART IN 1975.
IT IS PUBLISHED AS A CATALOGUE FOR THE EXHIBITION
AS APERTURE VOLUME 18 NUMBER 1
AND AS A BOOK FOR GENERAL DISTRIBUTION.
THE EXHIBITION AND PUBLICATION
HAVE BEEN ORGANIZED BY MICHAEL E. HOFFMAN.
THE PUBLICATION IS SET IN LINOFILM BODONI BOOK.
IT WAS PRINTED BY RAPOPORT PRINTING CORPORATION
AND BOUND BY SENDOR BINDERY.
THE DESIGN IS BY PETER BRADFORD
AND WENDY BYRNE.

APERTURE, INC. PUBLISHES A QUARTERLY OF PHOTOGRAPHY,
PORTFOLIOS, AND BOOKS TO COMMUNICATE WITH
SERIOUS PHOTOGRAPHERS AND CREATIVE PEOPLE EVERYWHERE.
A COMPLETE CATALOGUE WILL BE MAILED UPON REQUEST.
ADDRESS: ELM STREET, MILLERTON, NEW YORK 12546

Frederick H. Evans, hailed in 1903 by Alfred Stieglitz as "the greatest exponent of architectural photography," died in London in 1943, just two days before his ninetieth birthday. By chance, on a wartime mission to London in 1944, I saw the memorial exhibition of his photographs, organized by The Royal Photographic Society of Great Britain. Known to me only by the reproductions in *Camera Work*, the richness of Evan's original platinotypes overwhelmed me. I wrote my wife Nancy: "Evans must be reckoned as one of the great pictorial photographers. Surprisingly, the photogravures in *Camera Work* do not do him justice. It can be no exaggeration to write that his architectural photographs are the greatest of their kind, because he was able to combine precision of definition with a softness and delicacy of gradation and because he had an extraordinary sense of scale and of light. Detail is everywhere — every tracing, every lead of the stained glass windows is present — yet the result is far from a record: each print is an interpretation. He had one view of an attic of an old English house with hand-hewn beams that reminded me of Charles Sheeler. All the prints were platinotypes, and printed with that beauty which can only be appreciated when viewing the originals. Sometime we must introduce (or re-introduce) Evans to American photographers. There is a lesson to be learned from him — that one can be a "straight" worker and yet have delicacy and softness, integrity and yet not the harsh contrasts characteristic of so much present-day work. The hazards of shipping the prints during wartime preclude any planning of the show now, but sometime we may get a chance to exhibit a selection."

That opportunity came twenty years later in 1964, when, as director of George Eastman House, I organized an exhibition of 84 original prints. We had already acquired an excellent collection of Evans prints from his friend, Gordon Conn, and to this nucleus I added prints generously loaned by The Royal Photographic Society of Great Britain, London, The Library of Congress, Washington, D. C., The Metropolitan Museum of Art, New York, and the Art Institute of Chicago.

Evans was a prolific writer. As I read his many articles in the popular British photographic press and *Camera Work*, it became at once apparent that the catalogue of the exhibition would be incomplete without a biographical text explaining his philosophy of pure photography, which he defined as "the straightest of straight photography."

The catalogue has long been out of print. Today the teachings of Frederick H. Evans seem even more important than when they were written. With generous permission of the Trustees of the International Museum of Photography at George Eastman House, the text is now reprinted in its entirety, with a greater selection of plates.

I thank Evan Evans, for providing a number of prints of his father's work for reproduction: the staffs of The International Museum of Photography at George Eastman House, The Royal Photographic Society of Great Britain, The Library of Congress, The Metropolitan Museum of Art and the Art Institute of Chicago: Georgia O'Keeffe and Yale University, for permission to quote from the Evans-Stieglitz correspondence: *The Amateur Photographer*, for permission to quote from its pages and from *Photography*, which it absorbed: Peter C. Bunnell, David H. McAlpin Professor of the History of Photography and Modern Art, Princeton University, Robert M. Doty, Curator, Whitney Museum of American Art, New York, and Diana Edkins, for sharing and undertaking valuable research: Nancy Newhall, for helping me to sharpen my text and in the selection and sequencing of the plates: Michael Hoffman, publisher of Aperture, Inc., and Advisor to the Alfred Stieglitz Center of the Philadelphia Museum of Art, for undertaking this greatly enlarged edition, and for insisting upon the highest quality of production. *Beaumont Newhall*

The reproductions have been made, with two exceptions, from original prints by Frederick H. Evans. The greatest number are in the collection of the Alfred Stieglitz Center of the Philadelphia Museum of Art. The balance were loaned by Evan Evans through the kind assistance of the Carl Siembab Gallery, Boston, where the prints have been available for sale. Two reproductions have been made from copy photographs generously provided by the International Museum of Photography at George Eastman House, Rochester.

INTRODUCTION

At the turn of the century, when it was universally felt that the only way photography could hope to gain recognition as an art was by the most elaborate manipulation of negative and print, Frederick Henry Evans, a retired London bookseller, practiced and preached a doctrine of pure photography. He specialized in architectural, portrait and landscape subjects because he believed that they were most suited to interpretation by the camera. He developed his negatives mechanically, and printed them, without retouching of any kind, by contact on platinum paper, which he chose because of its ability to reproduce the rich tonal scale of the negative. He exhibited frequently and wrote extensively, with a result that his style was widely imitated, even plagiarized. His contemporaries hailed him as the greatest architectural photographer of all time, yet were perplexed and baffled by his seemingly endless preaching of a gospel of "the straightest of straight photography," which they felt limited the expressive potential. He was a relentless self-critic, obstinate, often opinionated, sometimes unreasonable, and always impatient with those who could not comprehend his "painful worryings and gropings after the ever-fleeting phantom of Perfection."

I. THE BOOKSELLER

He was born on June 26, 1853. Of his early life, parentage, education, we know little; recorded facts are limited to the recollections of a few friends, who remembered first meeting him in his bookshop on Queen Street, Cheapside, London. He was no ordinary bookseller. George Bernard Shaw, who was a frequent visitor to his ship, wrote:

It was jam full of books. The window was completely blocked up with them, so that the interior was dark; you could see nothing for the first second or so after you went in, though you could feel the stands of books you were tumbling over. . . . I took a great interest in the shop, because there was a book of mine which apparently no Englishman wanted, or could ever possibly come to want without being hypnotized; and yet it used to keep selling in an unaccountable manner. The explanation was that Evans liked it. And he stood no nonsense from his customers. He sold them what was good for them, not what they asked for. You would see something in the window that tempted you; and you would go in to buy it, and stand blinking and peering about. . . . "I want," you would perhaps say, "the Manners and Tone of Good Society, by a member of the Aristocracy". . . . "Ibsen, sir?" Evans would say. "Certainly; here are Ibsen's works, and, by the way, have you read that amazingly clever and thought-making work by Bernard Shaw, *The Quintessence of Ibsenism?*" and before you were aware of it you had bought it and were proceeding out of the shop reading a specially marked passage pointed out by this ideal bookseller.[1]

Employees from nearby financial offices in the city liked to spend their lunch hours browsing among the books. Evans welcomed them. He was so friendly, so stimulating in his talk, so informative, that the shop came to be called "the university of the City clerk." One of the most frequent visitors was an eighteen-year-old youth, Aubrey Beardsley, then working at the Guardian Insurance Company, and completely unknown as an artist. Evans liked his drawings so much that he exchanged books for them. When the publisher John M. Dent told Evans of his plan to publish an illustrated edition of the classic King Arthur legends, Sir Thomas Malory's *Le Morte d'Arthur*, Evans suggested Beardsley as an illustrator. "He had shown no hint or

evidence whatever of the peculiar style his genius developed into later," Evans recollected. "All I had to go by then was a certain freshness of idea, a more than hint of a positive and rare beauty of line, which instinctively made me feel that whatever he did for the 'Morte d'Arthur' would be at least out of the ordinary rut of illustrating. No one then could have foreseen the tremendous powers he was to express later; but it is a morsel to one's credit as a lover of beauty to have seen enough in him so early as to hazard such an introduction."[2]

Evans told the members of the Photographic Society of Great Britain in 1886 that he first took up photography because of his life-long study of the beautiful. He and his friend and teacher, George Smith, proprietor of the Sciopticon Company, a firm which made and published lantern slides, were showing slides made by Smith from negatives taken through a microscope by Evans of minute shells (*Polycistina, Quinqueloclulina excavata*), the eye of a water beetle (*Dytiscus*), a section through the spine of a sea urchin (*Echinus*). Photomicrographs of great beauty and definition, they had won a medal at the Society's exhibition, where they had been catalogued as "Scientific Slides." Smith said the title was a misnomer: "If that had been their real object they would in all probability never have been produced. They were, on the part of Mr. Evans, simply artistic studies in the fullest sense; and, on my part, an earnest endeavour to raise photography to that of a true art."[3]

George Smith believed in pure photography. "I am of the opinion that to *dodge* a negative in any way whatever, except the spotting out of unavoidable mechanical defects, is not art, but a miserable confession of inability to treat photography as a true art. . . . I contend that by due attention to the exposure of the negative and again to the positive, any artistic effect desired can be faithfully done by pure photography without any retouching whatever."[4]

It was Smith who instilled in Evans that impeccable technique and respect for the photographic medium which was to mark his mature style.

At the 1891 annual exhibition of the Photographic Society Evans exhibited a series of "At Home Portraits" which, to quote the catalogue, were "absolutely unretouched." Por-

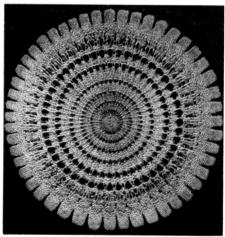

Spine of Echinus

traiture, he felt, was one of the few fields in which the photographer could better the painter:

I think portraiture by the camera can give a far greater, more intimate sense of identity than any save the work of the very greatest painters; and that, too, without the intrusion between it and us of the presence of the producer. What is wanted in portraiture is the portrait, and nothing more; no obvious intrusion, that is, of the personality of the producer; a true portrait, of course, an evocation, true to the spiritual and mental as well as the physical.[5]

He commemorated his friendship with Aubrey Beardsley with two memorable por-

traits. In one the artist holds his head in his long-fingered hands; in the other he peers forth like a figurehead, alive with perception. A friend remembered that Evans "spent . . . hours wandering around the gaunt youth, wondering what on earth to do with him, when Beardsley, getting tired, relaxed and took the pose which Evans immediately seized."[6] Although undated, the portraits were probably taken in 1894, while Beardsley was making the five-hundred drawings for *Le Morte d'Arthur*, for Evans mounted one of the prints within a decorative border the artist had drawn for the book.

In 1898, at the age of forty-five, Evans gave up his bookshop and retired with a small annuity. Financially independent, free to photograph what he chose, he now concentrated on architecture. He was to achieve his greatest success, and to make his unique contribution to the history of photography, interpreting the medieval cathedrals of England and France.

II. THE CATHEDRALS

Most nineteenth-century photographs of cathedrals were little more than highly skillful recordings. George Washington Wilson and James Valentine — to name two of the most popular photographers of famous sites and monuments — produced glossy prints by the thousand for sale to tourists. These recorded with brittle and profuse detail the fabric of the great buildings, both within and without, but the sense of space, of light, of the upward reach of every architectural element, of that transcendental heavenward soaring which is the glory of the medieval spirit, was utterly absent in them.

Evans was not content with passive recording. He wanted his photographs to be so true

and charged with feeling that looking at them would be equivalent to being in the very cathedrals themselves. "Try for a record of emotion rather than a piece of topography," he advised the beginner. "Wait till the building makes you feel intensely, in some special part of it or other; then try and analyse what gives you that feeling, see if it is due to the isolation of some particular aspect or effect, and then see what your camera can do towards reproducing that effect, that subject. Try and try again, until you find that your print shall give not only yourself, but others who have not your own intimate knowledge of the original, some measure of the feeling it originally inspired in you — greater or less, according to the success you have attained. This will be 'cathedral picture making,' something beyond mere photography; the

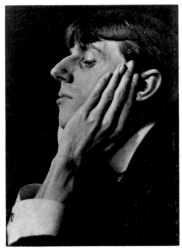

A. Beardsley by F. H. Evans

result to the critic shall be, not merely 'what a clever bit of photography!' but, 'What a noble, beautiful, a fascinating building that must be, and how priceless an art is that sort of photography that can so record one's emotional *rapprochement* to it!'"[7]

By photographing light, volume and substance, he wanted to lead the spectator

through space. His photograph of Ely Cathedral subtitled *A Memory of the Normans* was taken

> to suggest . . . contrasts in tone; rich deep shadows, full of soft detail, and as interesting and valuable in themselves as the other parts of the picture, together with the fullest sense of soft, sunlit piers and arches seen through them in the distant nave; and these, not so much as opposing lights as harmonising brightnesses, the inviting future, the goal beyond, as full of its own charm as the dark arches of the shadowed present we stand in to gaze at the hopeful vista beyond.
>
> The pure unforced curves of the light arches seemed very inspiring and inviting; and though I was fully content to stay and enjoy the glorious darks of the shadowed arches I stood amongst, I yet felt—and wanted my picture to make me again feel, when I was far away from the lovely spot, and perforce content with what I should take away as a record of it—that it would be even better to take the step over the threshold that should bring me into this most inviting and wonderfully lit beyond, the desired haven.[8]

Such photographs could not be taken casually. Evans would spend weeks living in the chosen cathedral. Every day he would study the light, carefully writing down in his note book the hour when it best revealed each portion of the church, an estimate of its strength, and the precise camera stance.

His friends told again and again how he photographed the nave and octagon of Ely Cathedral. For two weeks he waited, his camera case closed. Then, at last, he knew that the light soon would be right. But he could not set up his camera because chairs cluttered the floor.

He asked the verger to take them away, but was refused: today was Saturday, tomorrow there would be services. In his orange corduroy jacket, his green tie secured by a scarab ring, Evans marched to the Dean himself. The Dean found it better to agree than to argue with this dynamic little man, who peered at you so intensely through his thick spectacles. The Dean gave orders; the offending chairs were removed. Still Evans could not go to work. Hideous Victorian gas fixtures clashed with the purity of the medie-

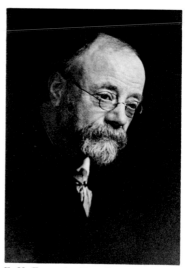

F. H. Evans by Hoppé

val carving; they, too, must be removed. He went and got a gasfitter to take them down. At last he made the exposure. The verger put back the chairs, the gasfitter put back the fixtures, and to the relief of the Dean and the verger the little man went away to develop his negative.

Only then could he judge his results. If he failed he laid the negative on the floor and starred it with his heel—and went back again to the cathedral. He would have liked to process his photographs on the spot:

> If it were ever possible for us to develop and print our pictures before leaving the place of their creation, we should be far more severe critics of our work, and strive after a far more severe ideal than we do, when, as we are mostly compelled, we develop and print, and lastly make our picture on paper, miles away from the place of the

subject, and, it may be, weeks and months after its being taken; during which interval the intensity of the original impression, and the clearness of the memory of its detail and other elements, have so far weakened as to make us cheerfully accept the best we can produce from the chance exposure we then made. We very likely get something quite nice, something that pleases us (and possibly our friends, if not too critical); but how often can we lay hand on heart and say that it is actually and faithfully what we tried for?

The painter or sketcher working at his positive image at the actual scene, can alter, correct, and re-correct; try again and again for what he wants to record; but we photographers, in our hurry to make as many exposures as possible, rarely or never complete our positive at or near the scene of its subject, and so we are unable to really criticise or properly correct what our chance exposure gave us. We are perforce driven to be content with making the best we can out of what that chance first exposure gave us.

My own ideal method of working at my architectural pictures would be, if it were possible, to live a whole twelvemonth round in the cathedral town chosen; develop and print everything; and only leave when I had, on paper, the record that satisfied me. As it is, I do, almost always, develop my exposures while there, repeating when I think I see that the negative will not print to give me what I want.[9]

Placement of the camera was always exacting. Evans had a Golden Rule: the camera must be as distant as possible from the subject, and a lens chosen from his battery of seven that would completely fill the ground glass with the desired image. He described how, photographing in York Minster, "I managed to fill my focussing screen with the subject and effect I desired, flooded with light yet not drowned in it. Until the camera adjustment was absolutely accurate, the light simply looked like fog on the screen, and would have been so had the lens been shifted

even to the 1/10 of an inch."[10] Exposures were long, because he invariably stopped down well, usually to $f/32$. "I always prefer to expose at as small an aperture as my time for exposure will permit," he wrote. "Large apertures tend to disintegration of image on some plane or other; and unless that is a special effect aimed at and that will justify itself in the result, it is a mistake, and only means pain and discomfort to one's eyes."[11]

Although Evans made several notable photographs of exteriors, such as the superb *Lincoln Cathedral from the Castle* dominating the city, soaring phantomlike above the dark, richly textured roofs, he preferred to photograph interiors. The art critic of the *Boston Evening Transcript*, reviewing an exhibition of forty-five prints in the studio of the photographer F. Holland Day, defined his style: "Mr. Evans's favorite pictorial arrangement for a church interior is a look from a shadowed place, between clustered columns, into a lighted part of the cathedral. With some slight variations he plays upon this theme with wonderful results. Not all the patient and labored detail of Haig's etchings, nor the elaborate paintings of Bosboom, conveys a hundredth part of the suggested grandeur which emanates from these unpretentious prints, in which compactness, architectural expression, and a sense of awe-inspiring mystery are blended in a single impression."[12]

The review must have pleased Evans, for he once said, "I felt that photography had something new to say in cathedral interior subjects, something that, in my egoism, I fancied had not been said from the sedate old Bosbooms to the modern theatrical Axel Haigs.". . .[13]

These two artists, almost unknown today, were highly appreciated in Evans's time. Johannes Bosboom (1817–1891) was a Dutch

painter who had revived the seventeenth-century architectural style and added to it a dramatic sense of light: his church interiors show strong chiaroscuro, they are filled with light; he kept the shadows dark and made foreground objects appear as silhouettes against brilliantly lit walls. Axel Haig (1835–1921) was a popular etcher. But if Evans felt he could outdo these minor masters, he humbly hoped he might approach the great Turner.

> Many years ago [he recollected in 1903], when visiting the Winter Exhibition of Old Masters at the Royal Academy, I saw for the first time some of Turner's early architectural watercolor drawings. What impressed me most was the superb sense of height, bigness, light, atmosphere, grandeur that this incomparable artist had managed to suggest within the few inches that comprise these small pictures. How hopeless for anything but the brush of so great an artist to accomplish so much in so little! And especially how hopeless for anything in the way of camera-work to compete with them in any sense! When, some time afterward, I began working at photography and found myself drawn to cathedral studies, I recalled these little masterpieces and wondered afresh if anything photography might ever do could merit a tithe of the praise so justly lavished on the incomparable Turner.[14]

Much as he respected paintings, and much as his vision was shaped by their study, he did not want to imitate them. He once wrote that architectural photography "calls for accurate drawing, good composition, and true effects of light and shade, and in an artist's hands photography is capable of adequately dealing with all these elements; and at the same time the results may be infinitely truer and more complete than we can look for from the average draughtsman or painter . . ."[15]

Though he might deny it, he created a personal style. He could write: "Our cathedrals are rich enough in broad and subtle effects of light and shade, atmosphere, grandeur of line and mass, to be content with pure photography at its best; nothing need be added from the artist's inner consciousness to make it more impressive or beautiful."[16] But his best photographs were so charged from his own inner consciousness with emotion, that critics called them poetic.

His style was a triumph of seeing. What he saw in the cathedrals he so loved others be-

Grote of St. Laurenskerk by J. Bosboom

gan to see. The *Photographic News* wrote that he "opened the door to a great number of other workers who now find material for portrayal by the camera where nothing could be observed before."[17] Amateurs set up their tripods precisely where his had stood. Ironically, the very imitation which Evans abhorred was turned upon him, and as an inevitable result his style became cliché. "Mr. Evans must feel very flattered indeed," *The Photographic News* remarked "as possibly no photographer has had the points of view he has chosen for his best-known pictures made use of more frequently."[18]

But he was not flattered. He was saddened and disappointed, and gently protested that

cathedral work of the ordinary kind, and especially of the imitative kind, is being very greatly overdone. . . . Poor Ely in particular is being treated with a familiarity bordering on contempt; one gets so tired of seeing the same old groupings that everybody had done being sent up again and again. When a point of view has been selected, and well treated, and exhibited with success, it should be a matter of indecency for it to be seen by the dozens of imitations for the next year or two. By all means let it be studied, and perhaps photographs made, by any or everyone; but do refrain from exhibiting them!"[19]

III. THE LINKED RING

Nineteen Hundred was a full year for Evans. He got married at forty-seven, had his first one-man show at the Royal Photographic Society, and was elected a member of the exclusive Linked Ring.

The Royal Photographic Society of Great Britain, founded as the Photographic Society of London in 1853 and honored in 1894 with the patronage of Queen Victoria, had become an establishment of great prestige. It was a world center of activity in photography's three branches—science, technology and art. To be invited by "The Royal," as the society came to be called, to hold a one-man show was a distinct honor. Although he had sent 120 of his photographs to the Boston, Massachusetts, Architectural Club in 1897, Evans had been seen in London only in group exhibitions and occasional reproductions in magazines. The 1900 show at the Royal Photographic Society established his reputation.

He hung a hundred and fifty photographs, mostly of architecture, but including landscapes and portraits. They were all platinum prints (or, as they were then called, platinotypes), and were in marked contrast to the "gum prints" then so popular with members of the society. These were made on drawing paper coated by the photographer with artists' water color pigment mixed with light-sensitive gum bichromate. After exposure beneath the negative they were "developed" with hot water. By applying the hot water with a brush, and by varying the temperature of the water, parts of the image could be emphasized and parts eliminated. The platinotype gave no such control.

At the opening he explained: My prints are all from untouched, undodged negatives, with no treatment of the print except ordinary spotting out of technical defects, or the occasional lowering of an obtrusive high light. . . . Plain prints from plain negatives is, I take it, pure photography, and as I am not an artist in the sense of being able to use pencil or brushes, however badly, I have been content with this; and the little successes I have occasionally been cheered by, encourage me to think that it is not such a bad road to travel by to the great goal of art. . . .

Photography is one of the finest methods for rendering atmosphere and light and shade in all the subtleties of nature's gradations, and for this we need an approximately perfect negative, and that perfectly printed fromThat is where the artist reigns supreme; *his* work is there, behind the camera; any radical error there can never be atoned for, no after treatment will make it 'come out right,' and no printing control will make it appear to have been the right instead of the wrong thing to have done. . . .[20]

The exhibition met with enthusiastic praise. *Photograms of the Year 1900*, an annual review of pictorial photography, commented, "In architecture . . . nothing shown by Mr. Evans or by anyone else has surpassed, in its own line, his delicately treated interior of one of the Kelmscott attics." The editor found a landscape "represented as no one else has done it," and concluded that "very

few men are so equal, and we recall none who is so equally strong in three departments (architecture, landscape and portraiture) so distinct."[21]

In the fall of 1900 F. Holland Day, an American photographer and an old friend of Evans, brought a collection of some four hundred photographs to London; billed as "The New School of American Photography," they were on display at the Russell Square house of the Royal Photographic Society. Day's exhibition was a sensation; the photographs in their strong linear, Whistlerian composition, their lack of definition, and subdued tones were entirely novel. Two young Americans were first seen in London at this exhibition: Eduard J. Steichen of Milwaukee, aged twenty-one, and Alvin Langdon Coburn of Boston, aged eighteen: both were to exert a profound influence on the future of pictorial photography in England.

Evans met Coburn at the exhibition, and they became friends. The older man enjoyed the youthful exuberance of Day and Coburn. There was the episode of the masquerade:

Holland Day had been to Algiers to make some "native" photographs [Coburn recollected] and he returned with a number of Arabic costumes, and so one evening we dressed up in some of them, and went to call on Evans.

There were then, as always, many foreigners in their native costumes walking the streets of London, and so no one paid the slightest attention to us, but Evans' housekeeper nearly fainted away when she opened the door and beheld us. Evans however rose to the occasion and did the obvious and entirely correct thing—he photographed us![22]

In November, 1900, Evans was elected a member of the Linked Ring, an organization dedicated to the promotion of photography as an art. This was a high honor; election was by invitation and unanimous vote. He found himself with the leaders of the international pictorial movement, including George Davison, Alfred Maskell, Alexander Keighley, A. Horsley Hinton of England; J. Craig Annan of Scotland, Alfred Stieglitz, F. Holland Day, Gertrude Käsebier, Clarence H. White, and Frank Eugene of America; Robert Demachy of France; and Heinrich Kühn of Austria. In 1903 Steichen and Coburn were added to the roster.

Evans was proud of this association, even though his doctrine of pure photography did not always fit well with the aesthetic concepts of most of the group, which led a wag to remark: "He is one of the few links between the 'Salon' and photography, and must at times 'feel quite out of it' amongst the Linked Ring. For his prints are all made from negatives . . ."[23]

He served as honorary secretary, and from 1902 to 1905 as "Idler"—the title bestowed upon the Link charged with full responsibility for handling the annual Salon.

The scheme which Evans worked out for hanging the 1902 Salon was revolutionary, and set a style which was universally adopted.

He transformed the skylighted gallery by covering the walls with jute canvas to the height of about nine feet. Around the floor and at the top of the canvas were moldings of ivory color. Vertical battens, two inches wide, divided the wall vertically into panels of irregular width. He suspended beneath the skylight a tent-like canopy of thin white cloth to diffuse the light. He hung the photographs in arbitrary groups within the panels, without regard to maker, separating the works of one man.

Evans had just finished hanging when he was interviewed by Ward Muir for *The Amateur Photographer*. Workmen were on ladders, a few framed pictures still lay on the

floor, and the room was littered. "The fight was done," Muir wrote, "and he had conquered. Hands in pockets, he viewed the results of his labours. His gaze was triumphant, albeit he was obviously very tired."[24]

The vertical division of the walls into panels was shocking at a time when little thought was given to the arrangement of photographs on exhibition wall beyond fitting as many as possible on the alloted wall space. Muir was greatly impressed:

> The amount of trouble he has taken over the hanging alone is hardly credible. Each picture had to be considered in relation to the others. Its tint, its size, its frame, its mount, its subject—all these were kept in view. Again and again a frame was tried in a certain spot, only to be rejected because the eye of the designer adjudged it to be unsatisfactory. In consequence of this extreme fastidiousness in grouping, every picture has an equal chance to look effective. Not a few of the photographs show up better on the Salon walls than they did when reviewed one by one on selection day. This means that a master-brain has been at work. Each section of the wall is itself a sermon in massing and composition. . . .[25]

Evans hung the next three Salons. The members were delighted. Their only complaints were that he tended to hang the pictures too high and did not put the work of one man together. It was believed that he unconsciously hung the pictures high because he was a short man. The hanging sequence was deliberate. "I have the feeling," he wrote in answer to this complaint, "that my first duty in hanging [is] to show *photography* off to the best, and . . . not that man or this or that country. . . . I often find it kindest not to hang a man's things together, it is too high a test and strain, only the biggest workers stand that and they not always."[26]

The presentation of photographs was always of concern to Evans. He perfected the type of multiple mounting which was called, inaccurately, the American style because of its popularity with the members of the New American School. The trimmed print was first fastened with dabs of paste at its upper corners to a colored card, usually a subdued gray or tan, hardly more than an eighth of an inch larger in size than the picture. This in turn was mounted on a somewhat larger card of a contrasting or harmonizing tint. The process was repeated, sometimes as many as eight times. The result was a series of borders around the photograph. Evans said the technique was "really an easier way of arriving at the French method of surrounding a drawing by ruling ink lines and filling up some of the spaces between them with faint washes of colour." Still it was exacting work, for each mount had to be of precisely the proper tint and cut exactly to the right size; it might take from five minutes to half an hour to get a satisfactory combination.[27]

Evans gave a practical course of instruction in mounting in a series of twelve monthly lessons in *The Photogram* magazine for 1904. In each issue there was a reproduction of a photograph, printed on one side only of a supplementary page. This the reader was invited to cut out, and to mount, according to Evans's explicit directions, on the cover paper—which was left unprinted on one side for this purpose. Not all of the cover paper was needed, and the reader was told to save the unused pieces for future lessons. Each month's cover was a different tint, so that by December the reader-student had a stock of mounting material, and was able to make an elaborate presentation. In 1908 Evans organized an exhibition of good and bad examples of multiple mounting at the Royal Photographic Society and gave a demonstration.

IV. CAMERA WORK AND STIEGLITZ

In 1903 Evans contributed a portfolio of cathedral photographs and an article to the fourth issue of *Camera Work*. This sumptuous quarterly was edited and published by Alfred Stieglitz, the leader of American pictorial photography. Each issue contained facsimile reproductions of photographs tipped by hand on mounts of colored card and Japanese tissue. Stieglitz was already a legend, and was as well known in England as in America and even more appreciated there. The first issue of *Camera Work*, featuring photographs by Gertrude Käsebier, was hailed by the photographic press. *Photography*, in its issue of January 3, 1903, said that in producing it "Stieglitz out-Stieglitzed Stieglitz."

Evans was the first English photographer invited by Stieglitz to contribute to *Camera Work*. He was delighted with this honor and wrote Stieglitz on March 13, 1903:

> I will do my utmost to make *my* number to be a big success, but please don't hurry it!
>
> I will send you my article and the prints next week I hope. As to gravures: I have lately had two of my best things done and in so sympathetic and perfect a way that I wish you would let me have the others done here and I could then relieve you of all anxiety and trouble, sending you the prints, passed by me, ready for binding up.

Stieglitz accepted this proposal. On April 17 Evans sent proofs, with a note: "I will of course pass *each* of the five thousand odd prints and I have conditioned that I am to reject any not good enough. I enclose my MS also, and hope it will prove to the point and sufficiently interesting. I very much desire and hope you will arrange to have an appreciation or two of my things, by some of your clever and delightful writers: of course

suppress my article altogether if you prefer . . ." Stieglitz suggested George Bernard Shaw as the author. Evans was pleased: ". . . he is an old friend and much admires my work. He says he will enjoy doing it only it must be in the shape of a 'character sketch' and not the usual thing about tones and values and so on 'he'd rather die first!' . . . I'm to dine with him tomorrow and take a pile of prints to talk over . . . I'm only praying that these prints may not disappoint *you*. I've tried them on artistic friends and

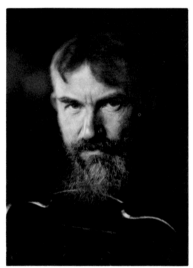

G. B. Shaw Self-Portrait

they are greatly approved for both subject and reproduction, so I live in hopes of pleasing you and New York."[28]

But alas the first shipment of prints did not please Stieglitz at all. Evans was greatly upset. "Your letter re prints depresses me intolerably . . . when you come to see them trimmed, all the white margins off, and the picture in a sympathetic colour mount, you will think better of them. I went over nearly all, I had but an afternoon for it, 4 days before the day to catch the steamer, and I rejected a great many . . . it may be that the reprints to fill up these gaps have not been as

good as those I passed, but apart from that I certainly thought the others were as good as the samples I sent over to you."[29]

Stieglitz cabled the printers, J. J. Waddington & Company, Ltd., to send the plates to him in New York for printing. They complied, with an apology for the quality of their work due, they said, to lack of time.

But it proved impossible to reprint the plates, and the fourth issue of *Camera Work*, dated October, 1903, appeared with Waddington's prints beautifully hand mounted, first on gray or tan submounts, and then on Japan tissue laid on top of the pages. The photographs Stieglitz selected were among Evans's best: *Ely Cathedral: A Memory of the Normans*; *Ely Cathedral: Across Nave and Octagon*; *Height and Light in Bourges Cathedral*; *York Minster: "In Sure and Certain Hope"*; *York Minster: Into the North Transept*; and *Ely Cathedral: A Grotesque.*

Stieglitz felt it necessary to insert an editorial note, explaining the circumstances of the printing and offering an apology for the quality of the reproductions. But despite his disappointment, Stieglitz wrote a moving tribute to Evans:

> The success of American photography having been achieved mainly through portraiture and figurework, the earlier numbers of *Camera Work* have been devoted chiefly to these; we therefore present in this number the work of Mr. Frederick H. Evans, of England, noted as the greatest exponent of architectural photography, as a contrast to our previous numbers and in order to show the possibilities of pictorial treatment in this realm of the inanimate.
>
> It has often been charged that devotion to the pictorial in photography carried with it an utter disregard of photographic technique, but the fact that Mr. Evans is a firm believer in and practitioner of the purest forms of photography disproves this assertion. He stands alone in architectural photography, and that he is able to instil into pictures of this kind so much feeling, beauty, and poetry entitles him to be ranked with the leading pictorial photographers of the world. His work once more exemplifies the necessity of individuality and soul in the worker, for of the thousands who have photographed cathedrals, none has imbued his pictures with such poetic qualities coupled with such masterful treatment.[30]

Evans wrote Stieglitz on September 26, 1903: "C-W — rec'd, good, very, in all but the reproductions — I can only hope that my copy is the very worst of the whole 1,000!! I am going to show it to W. Co. together with the proofs they gave me and they shall explain the difference! It looks as tho they did not reprint the prints I rejected, for I swear I never passed such foul looking things as are in my copy — bar the first one of course. Many many thanks for the refreshing words of praise to my work and I cheerfully accept all the odium I deserve for so stupidly believing the other people!"

Shaw's appreciation of Evans was lively. He opened his essay with the recollections of Evans's activity as a bookseller, then told how he discovered, to his delight, that Evans shared his interest in photography, and summed up Evans's esthetic approach:

> His decisive gift, of course, is the gift of seeing: his picture-making is done on the screen; and if the negative does not reproduce that picture, it is a failure, because the delicacies he delights in cannot be faked; he relies on pure photography not as a doctrinaire, but as an artist. . .[31]

Shaw spoke as a photographic critic. He had reviewed for *The Amateur Photographer* the 1901 and 1902 London exhibitions. There he had praised pure photography extravagantly, and had denounced control processes. Photographers who emulated painters and

fancied themselves the more artistic the closer they were able to force photography to imitate hand effects were outraged when he wrote ". . . I greatly prefer the photographers who value themselves on being photographers, and aim at a characteristically photographic technique instead of a sham brush-and-pencil one."[32] They could not take seriously Shaw's sweeping assertion that photography was superior to painting; they were bewildered by his conclusion: "As to the painters and their fanciers, I snort defiance at them; their day of daubs is over."[33]

Shaw's *Camera Work* essay was more measured in tone than his exhibition critiques, but it was still controversial; *Photography* magazine dismissed it as "a mere literary firework from the pen of Mr. Bernard Shaw, who has still to show that he is entitled to speak of photographs with authority."[34]

Evans's essay, "Camera-Work in Cathedral Architecture" was largely a repetition of his Royal Photographic Society lecture of 1900. He concluded with a moving statement of what cathedrals meant to him, and why he photographed them:

> And there are no more abiding memories of peace, deep joy, and satisfaction, of a calm realization of an order of beauty that is so new to us as to be a real revelation, than those given by a prolonged stay in a cathedral vicinity. The sense of withdrawal, an apartness from the rush of life surging up to the very doors of the wonderful building, is so refreshing and recreating to the spirit as surely to be worth any effort of attaining. When one comes to be past the fatigues of traveling, and has to rely on old memories, these old visits to glorious cathedral-piles will be found, I think, to be among the richest remembrances one has stored up.[35]

Evans became a regular contributor to *Camera Work;* between 1904 and 1907 he wrote seven articles, including reviews of the Photographic Salon. In issue No. 8, October, 1904, Stieglitz published a new reproduction of Evans's "*In Sure and Certain Hope.*" It was a rich, lustrous photogravure, with deep yet open shadows and brilliant lights. By way of explanation Stieglitz wrote that when J. J. Waddington & Company saw the completed volume they asked to make a new plate of this photograph. "We were delighted," Stieglitz wrote, "not only to give them the opportunity sought for, but were pleased as well that we could thus present to our readers an object-lesson in the great differences in reproductions."[36]

V. LESÉ PHOTOGRAPHY

In addition to his articles for *Camera Work*, Evans wrote regularly for *The Amateur Photographer* and *Photography*. These illustrated weeklies were devoted almost exclusively to pictorial photography. "The A. P.," as it is still affectionately known by its readers, was edited until his untimely death at the age of forty-five in 1908 by A. Horsley Hinton, a founder of the Linked Ring. *Photography* was edited by R. Child Bayley, also a photographer, and author of the standard textbook, *The Complete Photographer.*

The editorial content of these magazines was lively and controversial. Hardly an article was published which was not immediately attacked with vigor or applauded in the letters page or in articles as long as the originals. Some of Evans's best writing was defensive. But tempting as it is to collect his essays, out of context they often have little meaning and seem repetitious. One must read the magazines from cover to cover, week by week, to sense the eagerness, the excitement, the passion of the readers and writers. The weeklies were not only the chief

source of technical information to thousands of amateurs, but they were arbiters of taste. For Evans, they proved sounding boards for his ethic of pure photography.

In his most controversial article, "Imitation: Is It Necessary or Worth While?" in *The Amateur Photographer* for June 11, 1903, he restated his belief:

> Photography has a much better future as an independent art method for working in tone than if taken as a negligible base for the display of hand work, or used in slavish imitation of other processes or methods. . . . It is more imperative than ever that photography as a title be one we are not ashamed of, but rather to boast of as a new power in an artist's hands, and one that will enable him to express what would be less well and convincingly said by any other form of art expression.[37]

The essay was at once denounced. A. J. Anderson in *The A. P.* for June 25, 1903, called it "an unfortunate article; it is unfortunate in its title, it is unfortunate in its inception. . . . It is a cruel title, which carries a sting right through the article, because it insinuates that those departures from pure photography which Mr. Evans deprecates as unnecessary and contrary to the ethics of photography, were made from the most puerile and ignoble of motives, the motive of imitation, and that those who have made those departures were mere slavish imitators of other processes and methods, paltry plagiarists; and such phrases as 'slavish imitators of other art methods' keep the wound smarting. . . .

"Has not the pictorial photographer a perfect right to approach his subject in any manner he pleases, so long as he is honestly striving to express his inspiration? Has he not the right to combine his negatives, or sun down his prints, or work in gum in his attempts to interpret his impression? . . ."[38]

Evans gave Anderson a qualified answer. He said that he did not deny control processes; he deplored their misuse. "All my remarks on imitation and imitators were meant to refer only to those workers who are content that their crude, tentative methods of working up shall be so visible and obvious in the finished print as to suggest to the mind and eye an apparent attempt at imitation. . . ."[39] And he agreed that for certain subjects over which the photographer had little control of lighting, such as landscapes, gum printing was the only solution.

What Evans criticized was poor craftsmanship and weak seeing. He greatly admired the French photographer Robert Demachy, who was a master of the gum print and, following its introduction by H. Rawlins in 1904, the oil print. This process allowed the photographer to ink by hand a gelatin relief on a paper base by stippling it with a special brush made of bear's hairs. It gave maximum control, since the ink could be applied as desired. Demachy said, "It is a purely monochrome painting on somebody else's drawing—not photography—and the painter's rules must be followed implicitly, and with proper knowledge, or disaster will follow."[40]

Evans wrote an appreciation of some of Demachy's photographs in *The Amateur Photographer*. Anticipating the charge of contradiction, he explained: "It may possibly be thought by some that I ought, logically, to condemn, or at least find fault with, them as being, or verging on the lines of, the imitation that I recently inveighed against, seeing the large amount of hand-work visible in the 'Portrait' and 'Fantasie'; work, that is, that cannot rightly be considered as due to the camera and lens." He came to a justification, which he was to repeat again and again: "But I shall not do so, as I find them perfectly le-

gitimate examples of photographic art; the modelling of the face in the 'Portrait,' for instance, is the only essential part of the study, and is emphatically due to the skilled and artistic use of the lens, etc."[41]

Despite this praise for his work, Demachy wrote a blast against "the new old school of pure photography" in 1906, which attacked Evans and his followers. Originally published in *La Revue de Photographie*, a free translation of it by his fellow Link, Alfred Maskell, appeared in *The Amateur Photographer*.

> It would seem that pictorial photography on the other side of the channel is within measurable distance of a return to the practice and heresies of albumenised paper . . . so that a print purely artistic in its nature cannot be admirable unless it distinctly offers us the photographic character and the qualities of the medium carried to their highest degree of perfection. More than this, all the efforts of the photographer are to be directed to the perfecting of these special photographic qualities: that is to say, rapidity in seizing and registering the subject, range and delicacies of half-tones (drawing doesn't count), and the most careful avoidance of any approach in resemblance to a work of art in another system of monochrome, such as etching, dry-point, wash drawing, lithography. . . . The photographic character is, and always has been, an anti-artistic character, and the mechanically produced print from an untouched negative will always have in the eyes of a true artist faults in values and absence of accents against which the special qualities so loudly proclaimed will not count for much.

> We must beware of the praises so suddenly lavished by these writers on photography pure and simple. . . . For we find that they are angry at the growing resemblances to methods of art which are still incontestably superior to photography both in system and in the effects produced; they forbid us to take them as models; they exhaust themselves, in fine, in ingenious arguments tending to strengthen the barriers which we have been engaged in shaking down . . .[42]

George Bernard Shaw answered the attack with his usual vigor: "This outburst by our friend Demachy is pure *lesé*-photography. What is all this about 'the photographic character being an anti-artistic character'? About 'methods of art which are incontestably superior to photography'? Name these methods. What are they? I deny their existence. I affirm the enormous superiority of photography to every other known method of graphic art that aims at depicting the aspects and moods of Nature in monochrome. . . ."[43]

Evans took issue with Demachy's statement that photographic quality is not necessary in the negative. "The whole basis of pure, straight photography lies in this initial step," Evans wrote, and then, again driven by his admiration of Demachy's work, made a justificatory assumption: "I am certain that, for one, Mr. Demachy must produce perfect negatives." Yet, try as he might, Evans could not resist criticizing Demachy. Of a brush-developed print he asked: "Everything photographic has been wiped off it: why call it a photograph?" Yet he was still loyal to the Frenchman: "I own two of M. Demachy's choicest examples. I know both are due in their finest values to hand control, but this is not distractingly evident; their every inch tells me they are photographic; does that give me shame concerning them? Rather does it add to their triumph in my eyes."[44]

VI. THE PIANOLA

In his introduction to his translation of Demachy's article, Maskell drew a comparison between pure photography and that type of player piano called the Pianola. Pure photography, he maintained, was anti-artistic. "Un-

less we eliminate it we can never hope to approach true art nearer than the pianola approaches in music the soul of the musician and the touch of the human finger. *Qua* art, a pure photograph is but a pianola art, at the best."[45]

This pronouncement infuriated Evans, for he was as much a champion of the Pianola as of photography. He played the Pianola every day, when not traveling, from one to two hours. He had the pedals of his own instrument reduced from 24 lbs. pressure to 5 lbs. so that they became sensitive to the touch of his feet. His friend and fellow photographer J. Dudley Johnston, who shared his enthusi-

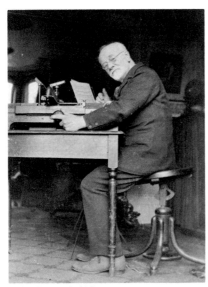

F. H. Evans Self-Portrait

asm for the Pianola, estimated that during his lifetime Evans "amassed a collection of some 1,500 rolls of his own cutting which must embrace practically all the masterpieces of piano music."[46]

Evans compared his Pianola to a camera; both, he felt, liberalized the boundaries of art by putting means of personal expression within the reach of everyone. This unorthodox belief he used as an argument in favor of

the creative potentials of photography. He gave a Pianola recital at the opening of his second London one-man show at the Camera Club in 1904; the program included Wagner, Bach, Mozart, Tchaikovsky, and the *Appasionata* sonata of Beethoven. *The Amateur Photographer* wrote that he gave to the Pianola "that individuality which very many, including himself, have imparted to camera work. . . . Dealing with the criticism that a pianola was merely a machine, Mr. Evans said that it was a machine—when a machine controlled it!"[47]

In 1911 Evans again played at the Camera Club. George Bernard Shaw introduced him:

Most of those to whom I am now speaking know Mr. Evans only too well. Mr. Evans has set a standard in photography that most of us find entirely impossible to live up to. He is a gentleman who has dedicated himself to an art which is disparaged by those who believe that when a lens is in a box it is mechanical, but not when it is in a man's head.

That being the case, it is natural that Mr. Evans should have done the same thing in connection with the art of music. Here also it is said to be mechanical to use a lever in a box, but not mechanical when the lever is to be found in the human hand. Using certain disparaged contrivances, Mr. Evans has shown pictorially the mastery of man over nature, and he has gone on from that to do the same thing in music.

If the piano is placed between yourselves and Mr. Evans, you will imagine that he is playing it in the ordinary way with his fingers. As a matter of fact, he is playing it with his feet.[48]

Some members were facetious. They asked Evans if he played more feelingly in his stockinged feet. Evans said he preferred slippers. Shaw predicted the day when the clumsy keyboard, adapted to ten fingers, would be eliminated entirely; this "would enable the composer of the future to do his work without

any regard to this mechanical limitation, and quite new arrangements of sound and tone effects would become possible."

VII. THE SPHERE

In New York the Photo-Secession had grown in importance under the leadership of Alfred Stieglitz. In 1905 two rooms adjacent to Steichen's studio at 291 Fifth Avenue were leased and made into "The Little Galleries of the Photo-Secession." The fifth exhibition was of British photographers, and Stieglitz invited Evans to send a collection of his cathedral photographs, to be shown during February with the work of J. Craig Annan of Scotland and his pioneer compatriot, David Octavius Hill, whose paper negatives of the 1840s, done in collaboration with Robert Adamson, Annan had reprinted.

Evans chose to make a retrospective collection of his best-known work, including photographs reproduced in *Camera Work*, fourteen from his York Cathedral negatives, some of the 1899 Ely Cathedral series, and his masterpiece, *A Sea of Steps, Wells Cathedral*.

The exhibition was reviewed by Roland Rood in *The American Amateur Photographer*.

FREDERICK H. EVANS

A sphere is a body every point of whose surface is at an equal distance from a point within called the centre. A sphere is at the same time the most perfect and the most incomplete of all bodies. It is the type of absolute symmetry, regularity and unity, but also of monotony. The conception of variation, rhythm and harmony cannot be attached to a sphere—only that of perfection. A sphere has the advantage over all other bodies in that it is the most easily comprehended. Start out from any point on its surface, and all directions are alike. From any given point all the rest appears identically the same as from any other point. The only difference in spheres is that some are larger and some are smaller.

Mr. Evans, honorary secretary of the Linked Ring, is a sphere. After having seen one of his thirty prints of architectural motifs being now shown at the Photo-Secession, one has seen all the rest. They vary from each other in size, it is true, but otherwise they are the same. The subjects are all different, but the pictures all alike. They are all perfect. The exposures have all been exact. The developments equally exact. The printing likewise. Every part, down to the minutest touch, is also perfect. All possibility of variation and irregularity and consequent harmony has been eliminated. They are the result of the most deadly exact calculation, but being such are incapable of arousing in the spectator any other than an icy feeling of admiration for their spherical perfection. For forty minutes I stood benumbed before them. More I cannot say, for it is impossible to criticise perfection.

In conclusion I wish to congratulate Mr. Evans on his spherical thought, ever circling around the centre, never receding, never approaching, always returning on itself, logical perfection of metaphysical expression.[49]

However debatable Rood's literary pretentiousness, his lack of sympathy is understandable, for the photographs were all well known from frequent reproduction and, to American eyes, the cathedrals seemed alike. Evans first read the parable of the sphere in what he could only imagine to be a condensation in the British *Amateur Photographer*, and asked Stieglitz to send him the original. The British press had consistently praised his work, and he could not understand Rood's lack of sympathy. "*What* does the — — fool mean?" he asked Stieglitz, in a letter dated June 8, 1906. "And why should I suffer under this eternal stigma of technical perfection—me, the rule of thumb man, the mere learner by experience not rules. All I want to claim

merit for is a sense for composition, a knowledge of when a subject is properly lit, and the ability to put that on the paper with more or less success. If Rood knew anything of photography (but does he know anything about anything?) he would be able as I am to discover many faults technically in my prints. And for a critic to be able to look at my collection of prints and see no poetry in them, no separate individual aim and result in each of them, no atmosphere, etc., etc., proves him no critic. . . ."

Even worse than the criticism was that only three prints were sold from the exhibition, and two of those before the show opened. Evans was bitterly disappointed that all he received was a check for $38.50. "My word what a surprising result! Will you kindly tell me what the honoured prints are that got sold and at what prices, I can then better estimate and value New York's temerity in such 'plunging.' "

Later that year he had another disappointment. For the first time in years he did not serve on the Selecting Committee of the Linked Ring, and he was most unhappy with the choice that had been made of the prints he submitted for the Salon. "Oh the things they 'chucked,' " he complained to Stieglitz. "They disregarded four of the freshest and best things I ever did and I'm sore I can tell you."[50]

Evans did not name the rejected prints but, like those selected, they were undoubtedly from negatives he had taken for *Country Life*.

This handsome illustrated weekly magazine had asked him to photograph exclusively for them. It was, he had written Stieglitz "a roving commission to [photograph] what I like, when I like and how I like, so long as I give 'em of my artistic best."[51] The assignment opened new fields and got him out of

the rut of photographing the great English cathedrals: he began to explore little-known parish churches and French chateaux. The assignment took him away from London during the summer of 1906, which was the reason why he could not work with the Linked Ring and the hanging of the Salon was turned over to Coburn.

Evans's style changed: Instead of the strong chiaroscuro of brilliantly lighted areas seen from shadowed foreground, giving a feeling of volume and space which characterized his earlier work, he now began to emphasize the substance of stone, the delicacy of sculptured detail. His *Sunlight and Shadow, Mont St. Michel* was called by *Photography* magazine "the most luminous and sparkling picture in the whole exhibition."[52] *Font, Birnham Priory* is bathed in light; the marble sculpture seems translucent. He concentrated on the object rather than the vista. Earlier he had led the spectator through arches and past columns and piers; he hoped "to suggest the space, the vastness, the grandeur of mass, the leading on from element to element, that so fascinates one going through a cathedral." He now lingered on details, and applied his mastery of technique to the revelation of craftsmanship rather than the re-creation of a mood. This change of seeing may have been brought about by the specific demands of his publishers, but was more probably a change of approach—else he would not have accepted the assignment.

The new style did not fit in with the pictorial concepts of the Linked Ring. He was on the selecting committee of the 1907 Salon, but again could not participate because of his commitments. The exhibition was a failure. *The Amateur Photographer* asked, "Where is the work of fresh inspiration that will give a new stimulus to progress? . . . It is time

for exertion, zeal, and ambition, not for clipping the wings of imagination and being content with merely doing well."[53] *Photography* was blunt: "We do not think . . . that the old R. P. S. at its worst was ever quite so bad . . ."[54]

VIII. THE DEATH OF THE SALON

Evans played no part in the 1908 Salon. Four of the twelve members of the Selection Committee were Photo-Secessionists: Stieglitz, Steichen, Coburn and Clarence H. White. Although Stieglitz and Steichen could not go to London and hence did not participate in the judging, Steichen and Coburn so dominated their fellow jurors that it was alleged that the Salon had become "an annex of the Photo-Secession." The Committee selected 203 photographs. Most of them were by the Committee members; half of them were by Photo-Secessionists. Some were represented by several prints, others by only one or two. Since the work of each man was hung together the result was a series of one-man shows of the favored few and oblivion for the majority, who were represented by only one or two prints, a fate which the editor of *Photography* stated to be "almost more contemptuous than complete rejection."[55]

Steichen led, with 39 photographs, including Autochrome color transparencies. Baron De Meyer followed with 28. Coburn was represented by 21. Nobody else had more than 10. Evans, like many others, was represented by one solitary print—a somewhat pedantic exterior of a French chateau titled *Le Moyen Age*. The editor of *Photograms of the Year 1908*, springing to Evans's defense, reproduced one of the rejected photographs, *La Maison Jeanne d'Arc, Rouen*, and explained:

> Frederick H. Evans' work has probably suffered from the fact that he has devoted a great deal of his time recently to photographing for *Country Life*, with the result that the selecting committees have a suspicion that his modern work is purely topographical. Much of it, necessarily, must be so, but this he does not submit for exhibition, and he is still producing new and individually seen results which are quite fit to stand alongside his best things of old days. The *Maison Jeanne d'Arc*, though frankly a piece of illustration, is excellent in every way, and if it had been done primarily for exhibition would have been accepted as a fine piece of Evans' work.[56]

Evans could not understand this rejection. He complained to Stieglitz, "I would not have growled or been disappointed had the *admit-*

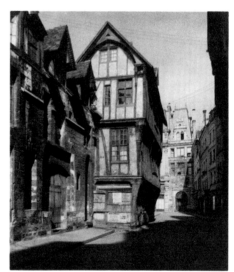

House of Jeanne D'Arc, Rouen

ted things been better than mine."[57] Referring to Steichen's two-tone gum prints, *Steeplechase Day* and *Grand Prix*, photographs of elegantly dressed spectators at the Paris racecourse taken with a hand camera instantaneously in bursts of spotty sunshine, he asked Stieglitz, "What is there of artistic vision or sensibility in them and what of the commonest technical knowledge; their double tones are abhorrent; no modelling, no planes, no gradation, no lighting of any truth, in short

no *photography* of any worth in 'em." He was disappointed with Coburn's photographs: "The way he has fallen back in his crude enlargements of underexposed snapshots is too feeble, truly pitiable. I am curious to hear if *you* will tolerate the vulgarity of his *Flip-flap*." This was a stark photograph of an amusement ride at the Franco-British fair: two vertical steel girders, each supporting observation cars, stand against a bleak sky like a pair of giant compasses, their points slightly separated.

Steichen, Coburn and the other younger photographers were striving towards a style that had little to do with Evans's concept of photography. To them the subject, the thing itself, was but the motif, the starting point for personal plastic expression; form, not content, dominated their seeing. To Evans the subject was paramount. He photographed because of an urge to communicate his deep feeling for what he found beautiful. "When one sees a thing," he wrote, "sees it vitally, that is, it becomes a matter of sheer necessity to get it down on paper; the instinct for production, for realisation demands it."[58] All his life Evans was a collector, and his architectural photographs were significant to him because the architecture was significant. The ugly structure of a fun fair was a thing meaningless to him; he could not accept the challenge of the image abstracted from the subject; thus *Flip-flap* was monstrous because the thing to his eyes was monstrous.

Nothing could be further apart than Steichen's *Steeplechase* at the Salon and Evans's rejected *Maison Jeanne d'Arc*. Steichen sought to hold forever the form of a particular instant of time. Evans sought to make pictures that would be as timeless as the buildings and landscapes they portrayed. Steichen exposed in the fraction of a second to stop the action of the restless, ever moving crowd; Evans chose a film of slow speed to give a massive, five-minute exposure so that the fleeting images of the passersby on the streets of Rouen would not be recorded on the negative while the lens was opened. He boasted of this technical accomplishment: "This street was full of traffic, road and foot-paths, all the time of exposure," he wrote on the back of the mount of the print now in the George Eastman House collection.

His intention was not "to erect the moment's monument," to use the words that Dixon Scott, a fellow contributor to *The Amateur Photographer* chose to express the dynamic character of a portrait by J. Craig Annan. Scott wrote that the photograph "does something no painting could ever do. It catches life in mid-leap, flushed and impetuous. It accepts the flutter and flash of that leap for its motive, and makes it the base of its pattern."[59] And he concluded, "Scenes and groupings torn out of the impetuous life of the hour are suddenly made momentous, given a new glamour and significance, and that, one likes to believe, is, after all, the special function of this new-born art of ours." Evans replied, in the next issue of *The A.P.*: The fact that such vividnesses are so accidental in their happenings, are so unsought, will always make them the exception and not the rule."[60]

For Evans based his photographic esthetic upon the static and the eternal. The concept of the camera as an extension of the eye, ever ready to catch segments of the passing scene so swiftly that the taking often seems more accidental than deliberate, was beyond his comprehension.

Embittered by his rejection at the 1908 Salon, Evans joined a group of dissenters who had rallied around F. J. Mortimer, the

new editor of *The Amateur Photographer.* Mortimer organized a *"Salon des Refuses"* at "The A. P. Little Gallery." Evans sent his rejected prints to it and denounced the work of the Selecting Committee as "The Salon Fiasco." Stieglitz chided Evans for doing this, and in a review of the controversial Salon in *Camera Work* Joseph T. Keiley officially reflected the disapproval of the Photo-Secession. "So active a member of the 'Ring' as F. H. Evans, an ex-Secretary . . . seems to feel that to have exhibited repeatedly in the Salon in the past and to have been an earnest supporter of the exhibitions that showed his work gave him an inalienable right to be accepted as an exhibitor perpetually, and to feel released from all loyalty to the organization as soon as it turns his work down."[61]

Seven members of the Linked Ring resigned in protest to the charge of American domination. They were all of international fame and influence: Alfred Stieglitz, Clarence H. White, Alvin Langdon Coburn, Frank Eugene and Joseph T. Keiley of the Photo-Secession, plus Baron Adolphe de Meyer and Heinrich Kühn. Bayley wrote in *Photography* that "the actual management of the 'Ring' has passed to men who have none of the enthusiasm for pictorial photography which characterised its initiation, and who have no real conception of the pictorial movement as it really is. . . . The centre of interest in these matters has passed from the Photographic Salon in England to the Photo-Secession in New York."[62]

Despite this blow, *Camera Work*'s accusation of disloyalty, and his bitterness over his rejection, Evans stuck with the Linked Ring, and accepted an invitation to join the Selecting Comittee for the 1909 Salon. But, to judge from his own review in *The Amateur Photographer*, it was a weak exhibition. "The prom-ise of pictorial photography is higher than ever, even though its individual achievement this year is not startlingly greater. It is very wholesome to find so high an average of imaginative work; but when one recalls the innumerable 'shocking examples' that were among the crowd of rejected prints, one cannot but feel the edge of one's elation to be taken off."[63]

There were two surprises at the Salon: the inclusion of twenty-eight photographs by David Octavius Hill, already hailed as an "old master," and an impromptu talk by George Bernard Shaw. The Hill photographs were overpowering. "Though one has known and admired them for years," Evans wrote, "they seem more potent than ever; it is a staggering display, reducing our current portraitists to a very poor place in comparison."[64] Shaw's speech, to judge from two different resumés in the photographic press, must have been brilliant; unfortunately it was not reported verbatim. He extravagantly denounced painting as simpler than photography, and told how Evans spent five days printing one negative and how much labor Coburn expended in making his portraits. He concluded with a plea for an historical exhibition; that, he thought, might rally an interest in photography which, to his regret, he saw on the decline.

Photography reported that during the ensuing discussion one member who was called upon to speak "said he had been so bewildered by Mr. Shaw that he would prefer to be excused." Ending the report, *Photography* continued: "Mr. F. H. Evans described the lecture as a good piece of log-rolling . . . As regards his negative which took five days to print, he had no remembrance of it, but he supposed it was so if Mr. Shaw said it. He thought the lecturer was hopelessly wrong in

many of his statements, but he would not dispute with him in public."[65]

Others besides Shaw noted a growing apathy towards photography. One by one the public press and art magazines stopped reviewing the exhibitions. The weekly photographic column of the *Pall Mall Gazette*, for example, was dropped. In 1910 Bayley, attempting to analyze the reason, suggested that it was due to the popularity of the control processes. He noted that gum prints, oil prints and the modification of the latter named by Mortimer "bromoil" dominated the Royal Photographic Society exhibition:

> The photographer visiting the exhibition may be forgiven for thinking that pure photography is somewhat at a discount, and that if he is to do pictorial work at all he must acquire some of the painter's dexterity as well as that of the photographer. He will think pure photography is discouraged. As indeed it is.[66]

On September 27, 1910, Bayley proclaimed, "The Linked Ring is *dead*."[67]

Some of the members, however, had regrouped, to form a new organization, The London Salon Club. Evans joined, much to the disappointment of some of his friends.

R. Child Bayley to Frederick H. Evans, June 13, 1910. I hope you will forgive me for saying that I was very sorry to see your name amongst its supporters. . . .

Evans to Bayley, June 16, 1910. It's this-a-way: when we Links agreed to forego our Annual Salon, many of 'em held a meeting and arranged to hold a show of their own, and at the same gallery. I held aloof, on the ground that I was sick of cabals, intrigues, jealousies, etc., and, that they couldn't worthily fill such a gallery. But when they told me they had secured a footing at the Fine Arts Society's Gallery . . . I gave way on the ground that . . . so important a locale meant the chance of a good and a useful exhn., and that my influence in the selecting would be of

real use in keeping out all mediocre or dead work. I joined on that understanding and they are all as keen as I am in having a really Pictorial show, worthy of such quarters.

Stieglitz also protested, and Evans sent him copies of his correspondence with Bayley. Stieglitz was then collecting photographs for the International Exhibition of Pictorial Photography which the Photo-Secession had been invited to hold at the Albright Art Gallery in Buffalo, New York, from November 3 to December 1, 1910. This was the most important exhibition of photography as a fine art that had yet been held in America. Eight of the museum's sixteen galleries were turned over to the Photo-Secession. The installation was supervised by the painter Max Weber, who transformed the galleries in a style similar to the decoration Evans had worked out for the Salon eight years before. Six hundred photographs were shown by leading photographers both in Europe and America. Evans sent twenty prints; eleven were hung. He acknowledged receipt of the catalogue: ". . . it is select and fine, you may well be proud," he wrote Stieglitz on a postcard, and added, as if to wipe out the bitter criticism of the past years, "I have resigned from the London Salon."[68]

IX. OLD MASTER

The coronation of King George V on June 22, 1911, in Westminster Abbey, gave Evans a unique opportunity. Everything movable in the cathedral had been taken away in preparation for the ceremonies and for the first time in centuries the great church was uncluttered and the mosaic floor could be seen in its entirety. Evans was commissioned by *Country Life* to make a series of photographs of the Abbey. It was for Evans a dream

come true. Back in 1904 he recorded in *Camera Work*, "I lately dreamt that I had the overseeing of a huge National Photographic Record. . . . I had such autocratic authority that I was able to deal at will with persons, or buildings, or even with street life, by having the police stop all traffic at the point and at the moment of my required picture. In buildings, even in our conservative cathedrals, I had the Governmental right to remove benches, pews, chairs, wherever I listed; to erect a scaffold where I chose, for the record of a bit of precious detail otherwise invisible."[69]

But the photographs of the Westminster Abbey series do not compare with his earlier work: the sense of volume and light is less vivid, and that delicate revelation of detail, substance and texture which characterized his best work is lacking. It was almost as if the job was now too easy, and that his urge to take advantage of the opportunity led to a too-hasty choice of camera stance and the taking of too many photographs, which today seem monotonous. Evans was very proud of them. He sent Stieglitz two, with a note: "The 'Across the Transepts' is to me as fine a piece of atmospheric and spiritual truth as the camera need be expected to help us to. Do slate [criticize] these two prints to your utmost possible, or if you should happen to approve—why, *how* set up I should be of course; tho I'm really too unregenerate to be influenced by any but my own desires."[70]

He was doing his best work in landscapes. As if to mark his revival of interest in the field, he sent an 1894 forest scene to the 1909 Salon. Tall trees march like the pillars of the nave of a great cathedral beside a road until their forms are lost in the dark forest. It was a picture which the writer George Meredith liked, and Evans made a new, enlarged copy of the fifteen-year-old platinotype as a token

of appreciation. But before Evans could deliver the photograph to him, Meredith died. In tribute Evans titled the print *Dirge in Woods*, and pasted on the mount Meredith's poem of the same title. He contributed eleven photographs to the 27-volume Memorial Edition of the works of George Meredith (London: Constable and Company, Ltd., 1909–1911). Among them *Deerleap Woods*, which appears as frontispiece to the third volume of poems, is most original. He became absorbed by the rendering of uneven, flickering forest light; one of his photographs he named *Spilt Sunshine*. He attempted to use a portrait lens to induce a moderate degree of that spreading of the light characteristic of soft focus to record the brilliance of sun flecks.

Besides forest scenes he photographed mountains and in France rivers with poplars lining their banks. He exhibited these photographs with Biblical quotations and passages from French poets pasted on their mounts.

As he grew older, and it became increasingly difficult for him to carry his heavy camera and massive tripod, he found satisfaction in photographing his art collection. He approached this work as he approached architecture, with humility, with the urge to recreate the esthetic content, and with impeccable technique. He wanted to record the substance and form so vividly that the photograph would convey the emotions aroused by seeing the original. In an article "Technique—No Art Possible Without It," he used photographs of Japanese sword guards to illustrate his ideal:

Their perfection (and no imperfect work of the kind should be exhibited) consists in their giving in black and white the same pleasure, the same idea, the same realisation of style and stuff, as one had in seeing the original; therefore, if the originals were art, the copies are equally so, a re-creation in

other terms. The special characteristic of each must be so brought out, so emphasised, as to give the beholder the same order of joy as the original. But that is artistry, not technical slavery; it is the artist in photography equalling the artist in sculpture or other subject, minus only the creative imagination.[71]

Most photographers consider the copying of prints and drawings a mechanical task, to be avoided. But to Evans even this work was a challenge, and his copies are so perfect in reproduction that it is often hard to believe that one is looking at a photograph and not the original. In 1912 he privately published, in an edition of twenty-five, seventeen platinotype reproductions of *William Blake's Illustrations to Thornton's Pastorals of Virgil*. He enlarged the 3 by 1-3/8-inch engravings to 5-7/8 inches wide, so that the fine detail could be appreciated without recourse to a magnifying glass which, he felt, destroyed the overall effect. He made similar enlarged copies of three wood engravings by Calvert Jones, and the forty-nine illustrations of the *Dance of Death* by Hans Holbein. The latter he published first in platinotype prints in 1913, and then by photoengraving in a handsome volume printed by hand in an edition of two hundred and fifty in 1916. He copied his collection of Beardsley drawings before they were sold in 1919, and published a charming small portfolio, *Grotesques by Aubrey Beardsley* with a miniature copy of his portrait of the artist mounted on the cover within Beardsley's ornamental border drawing.

Except for his copies of works of art, Evans had practically retired from photography by the time of World War I. He had no interest in those experiments in abstract and expressionist painting which were even then swelling into the great wave of modern art. The Post Impressionist exhibition organized by Roger Fry at the Grafton Galleries in 1910 had not impressed him favorably. He wrote Stieglitz: "I enjoyed much of Cézanne, Picasso, Gauguin; more of Van Gogh (a great master really), Matisse in nothing that was shown here, he is simply stupid. . . *I could draw better and colour also if I dared make such an ass of myself!* The critical newspaper reviews also have been great fun. I went more than once so as to be fair to 'em, but didn't alter my opinion. For most of 'em I consider they'll be without influence as they've too wholly lost sight of *beauty* either in line, mass or juxtaposition of colours, and Art minus beauty is to me unthinkable. . . . But it's all tentative, the new movement, nothing scarcely really accomplished, so 'we shall see what we *shall* see.' "[72]

In 1915 he asked Stieglitz to send him "for auld lang syne" the "291" issue of *Camera Work*. This was a collection of statements about the exhibitions held by the Photo-Secession, which had become almost exclusively non-photographic. Stieglitz sent a copy, and also the first issue of a new magazine, called simply *291*. Evans was bewildered by it. Stieglitz had reproduced a drawing by Picasso. "Was it a cruel joke of yours," Evans asked him, "to print it on its side, to make it seem worse still? Are you after all only laughing in your sleeve at 'em? When does the camera and lens begin to distort nature in the Picasso fashion?"[73]

The answer came two years later, when Evans's old friend Alvin Langdon Coburn held an exhibition in February, 1917, at the Camera Club of abstract photographs. These were taken through a system of mirrors so that all recognizable form was distorted. The resulting images were called "Vortographs" by Ezra Pound, leader of the Vorticist group of writers and painters.

The show, which also included paintings

by Coburn, was a sensation. Evans exploded. In a letter to the *British Journal of Photography*, which appeared in the February 23, 1917, issue, he quoted a child's version of a nursery poem beginning "Dordy mady iddy far. . . ." Only the nursemaid, he said, knew that what the child meant was "God, He made the little fly." He found this babble "an exact parallel" to the unintelligibility of the vortographs. He called it a "scandal" to publish "such futile rubbish" as Coburn's foreword to the catalogue. And as for his friend's paintings: "Phew!! Any nursery could beat them any day. . . ."

This outspoken criticism brought forth an immediate reply from Coburn: "When he started off by quoting that really fine poem, " 'Llordy mady iddy far,' [sic] I began to have hopes that he was really beginning to be converted to modernity, but then I discovered he was only looking for a job as a nurse.

"Mr. Evans thinks it would be an ideal state of affairs if everyone always took themselves and their work very seriously, but imagine how dull it would be; almost as dull as architectural photography!"[74]

Evans answered: "My criticism is, of course, in no sense a personal one. It is a battle of ideas and their expression. I have known Mr. Coburn since his teens, and have admired very much of his work. . . . The mistakes these youngsters make is to suppose that because they are bored with the feebleness that Art of all kinds always abounds in they must necessarily invent some bizarre and eccentric method and subject. But it is only necessary to see the strangeness, the newness in any subject, strange to other eyes, and to render that perfectly and with full meaning. . . . But, however strange and new, it need not (must not, to be sane) be bizarre or eccentric; if it is

only intelligible to its maker it is not really endowed with intelligibility."[75]

This letter made Coburn sad, "for I am fond of Evans, and hate to see him stagnating into a complacent worshipper of 'Old Masters. . . .' You see, Evans is getting to be a bit of an 'Old Master' himself. In his own field he has done work of an extraordinary perfection of craftsmanship, but quite evidently he does not like to be faced with new problems that have to be seriously thought

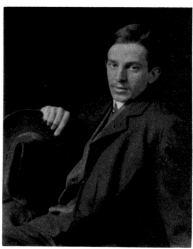

A. L. Coburn

about. He has become, one might almost say, an institution in the photographic world, so that an Evans architectural print is a thing to be spoken of with bated breath; but to become as successful as this is dangerous, and should be avoided at all hazards, as it leads, as I said before, to dulness and respectability. Mr. Evans is perfectly satisfied to go on translating cathedrals into platinum prints indefinitely, but even he must realise that it is a recreation that would bore, after a time, any worker cursed with that quality called imagination."[76]

Evans closed the correspondence: "Mr. Coburn mistakes . . . my attitude to cathedral photography if he imagines I am content

with retreading the same old ground in the same old way. If I were younger and deeper in pocket, I would start afresh and take cathedrals new to me (Spain for choice) and abandon my hard and fast anastigmats and work only with soft-focus lenses for their pencil-like, round-edged effects. I believe a wholly new joy in architectural photography is possible here, seeking mainly for fully lighted and richly shadowed effects. The imagination I am accused of not being cursed (blessed?) with rises in ecstatic joy at the mere thought of these unexplored fields of sane art; but though I feel as young as the youngest inside, I do feel certainly that my bones are getting old; the spirit is still willing, but the flesh grows weaker. Let me commend this new work to the younger generation, who prefer good work to mere publicity."[77]

X. A RICH AND FULL LIFE

The Royal Photographic Society elected Evans an Honorary Fellow in 1928. He was then seventy-five and almost forgotten, and his friend J. Dudley Johnston, past-president of the Society, had to remind the Council of the eminence of the candidate.

During World War II Alex Strasser interviewed Evans for *The Saturday Book*. He found him, at eight-nine,

> mentally as active as ever. In his neat house in Acton, [West London] with his wife and daughter, he leads a quiet but still rich and full life. Small, gnome-like, a fringe of white hair covering cheeks and chin, wearing a black velvet jacket, a blue silk tie, slippers and, occasionally, a skull cap, he skips round his room with immense agility, busying himself with many things. He is still interested in current literature, but for real relaxation he turns to his Pianola, for which he has himself cut 1500 rolls of music. His rooms are filled with numerous treasures which constitute his links with the past. Paintings, drawings and photographs crowd the walls. A strange-looking mechanical contraption of uncertain purpose in one corner and the roll-cutting machine in the other are puzzling to the casual visitor.
>
> Evans regards his photographs as his greatest treasures. And he is right. As things are, the cathedrals of England are in danger. His pictures will forever reflect their beauty. They are contributions of a true artist to his country's culture.[78]

On June 24, 1943, Evans died, just two days before his ninetieth birthday.

The Royal Photographic Society held a memorial exhibition of one hundred photographs in November, 1944, and invited seven of Evans's old friends to a symposium in his praise. George Bernard Shaw could not attend, but sent a message which was read together with his *Camera Work* appreciation. Alvin Langdon Coburn summed up the expressions of love and respect of his colleagues:

> Evans laboured in the dawn of pictorial photography's fight for recognition as a means of personal expression. The fight is won now, and photography holds an honoured place among the graphic arts, but whenever and wherever the tale is told, as legend or history to the young photographers of the days to come, the name of Evans will be remembered as one of the champions of the purity of photography who worthily contributed to the final victory.[79]

What can be known about God is plain,
for God has shown it. . . .
Ever since the creation of the world
his invisible nature . . .
has been clearly perceived
in the things that have been made.

Paul, *Romans 1:19–20*

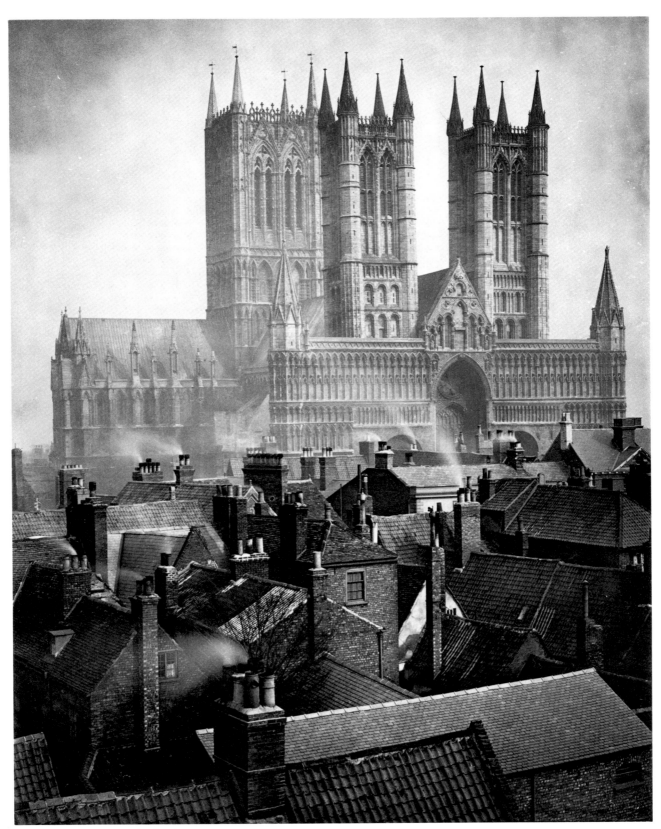

Lincoln Cathedral: From the Castle

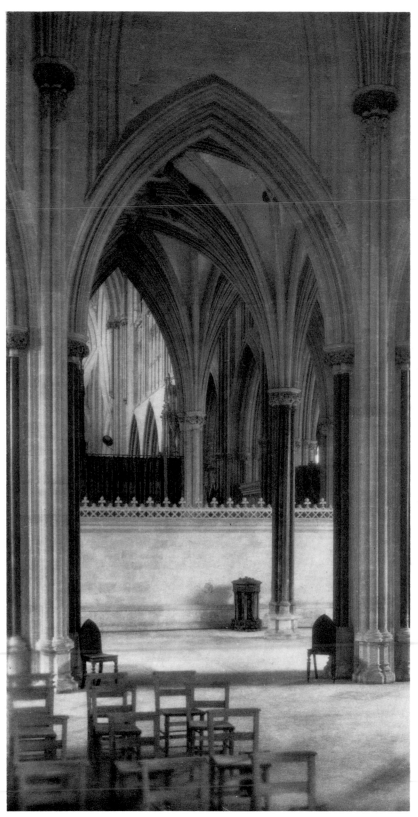

Wells Cathedral: Rehearsal Choir Into Choir

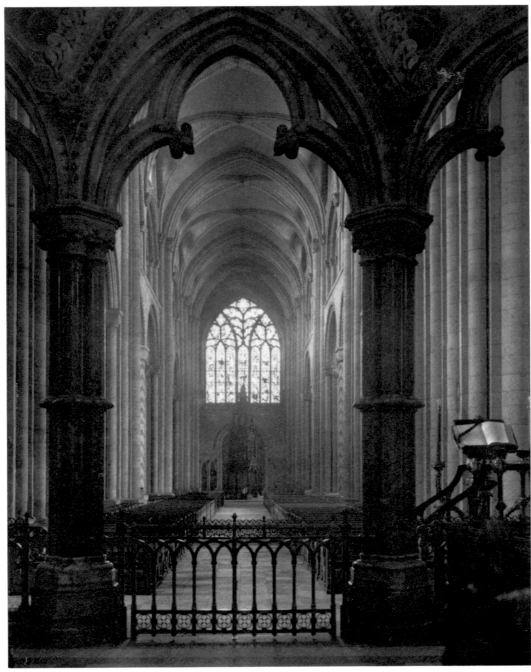

Durham Cathedral

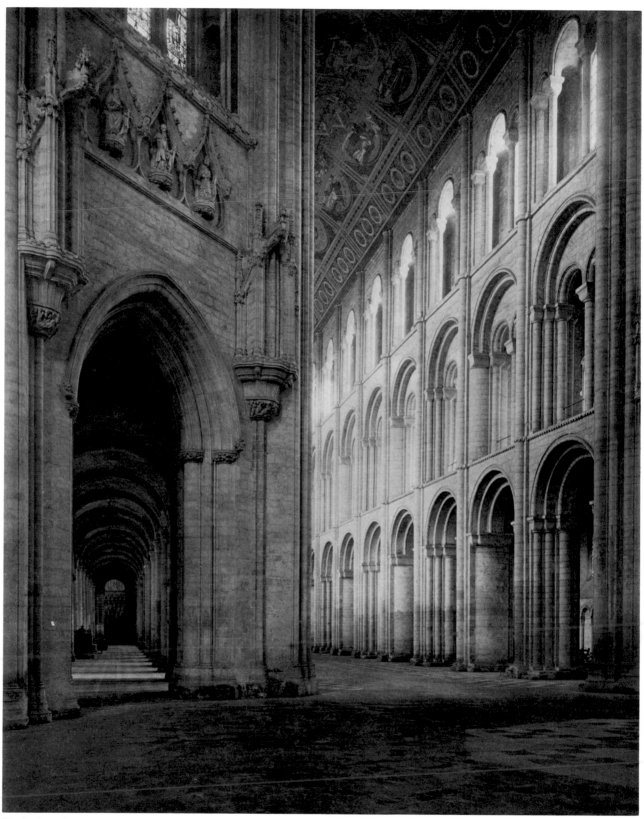

Ely Cathedral: Octagon Into Nave Aisle

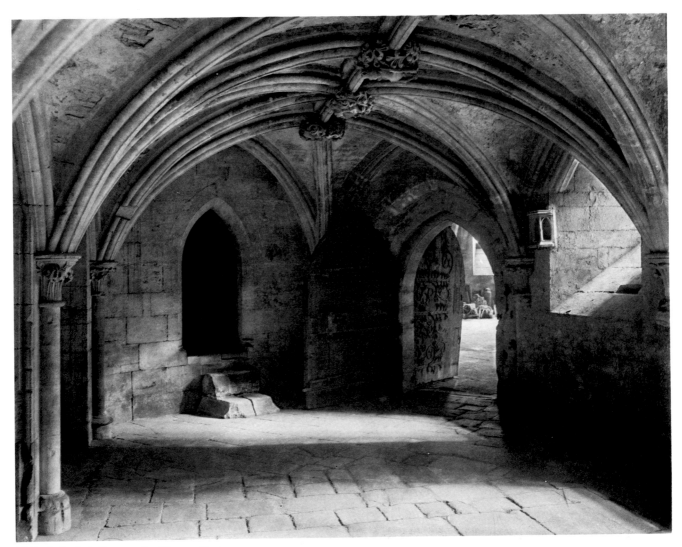

Wells Cathedral: Crypt under Chapter House

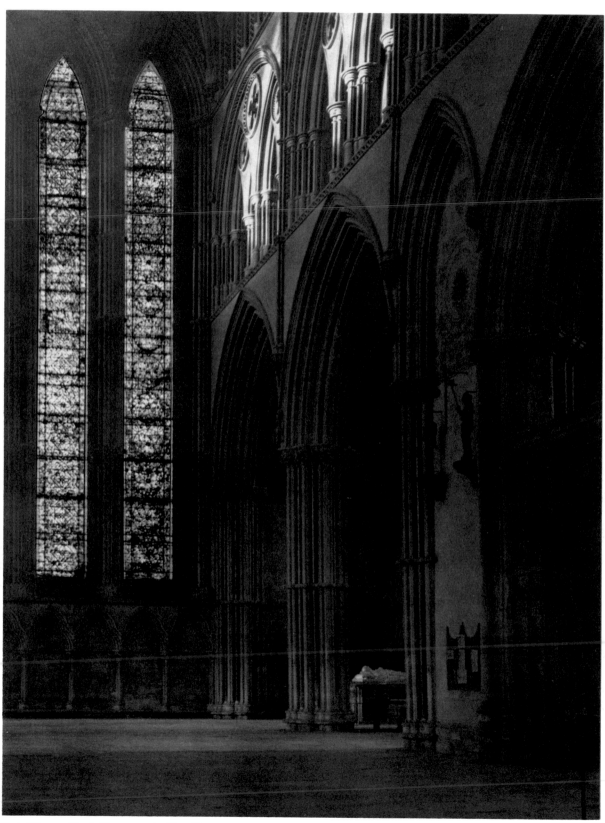

York Minster: North Transept, the Five Sisters

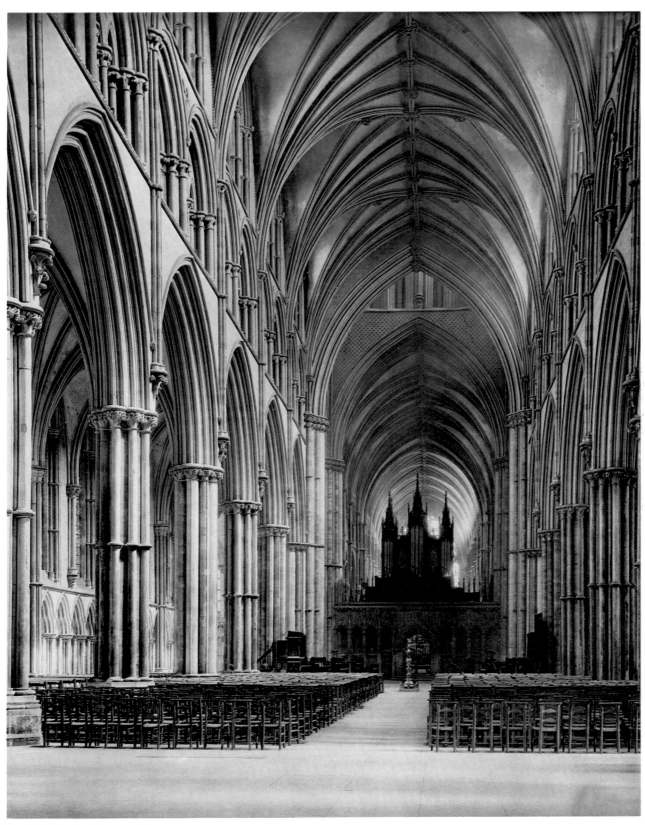

Lincoln Cathedral: Nave, to East

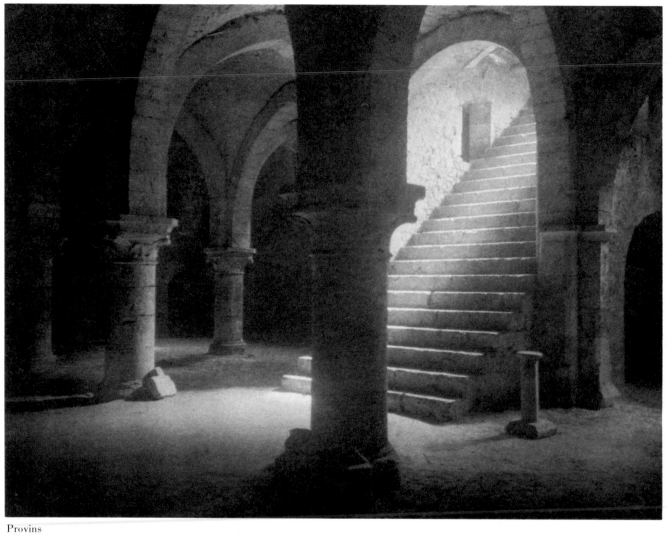

Provins

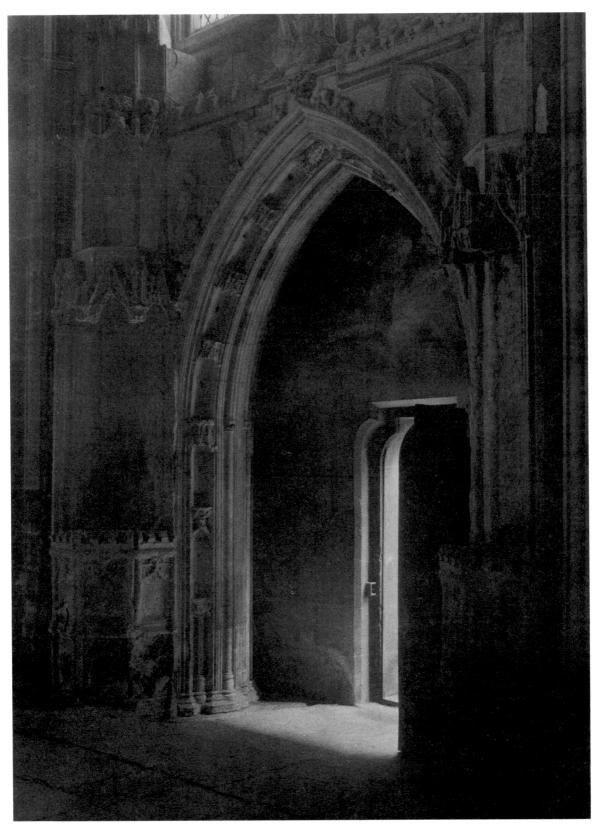

Ely Cathedral: Doorway to North Choir Aisle

Here then are a few words about a house
that I love; with a reasonable love
I think; for though my words may give
you no idea of any special charm
about it, yet I assure you that the
charm is there; so much has the old
house grown up out of the soil and the
lives of those that lived on it;
needing no grand office-architect, with
no great longing for anything else
than correctness. . . ; but some thin
thread of tradition, a half-anxious
sense of the delight of meadow and acre
and wood and river; a certain amount . . .
of common sense, a liking for making
materials serve one's turn, and perhaps
at bottom some little grain of sentiment.
This I think was what went to the
making of the old house.

William Morris, *On Kelmscott Manor*

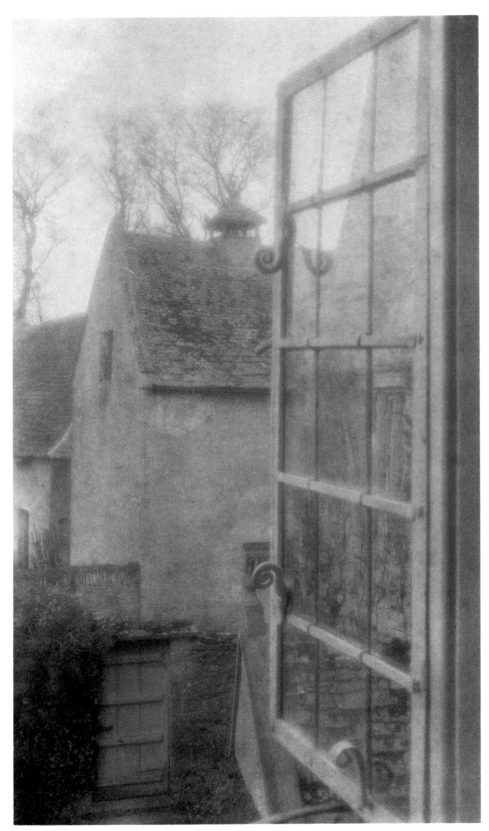
Kelmscott Manor from window of the Tapestry Room

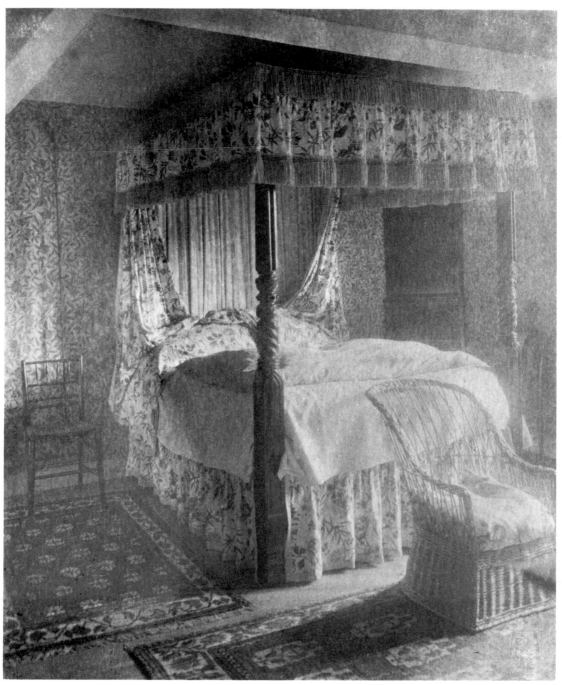

Bed in which William Morris was born

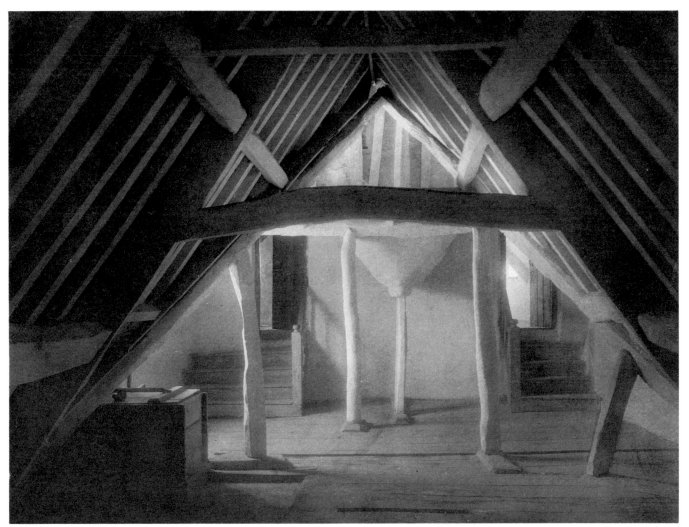

Kelmscott Manor: Attics, 1896

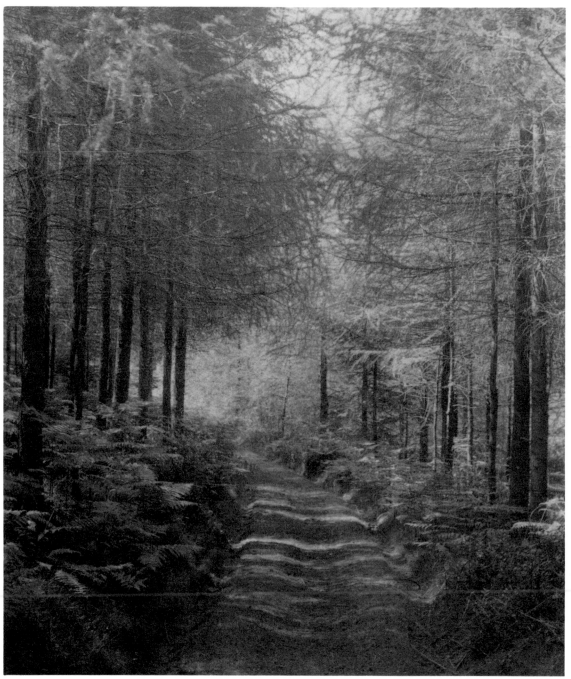

The Redlands Woods

New Forest

Borrowdale

A Mountain Shoulder

Redlands Woods: Late Snow

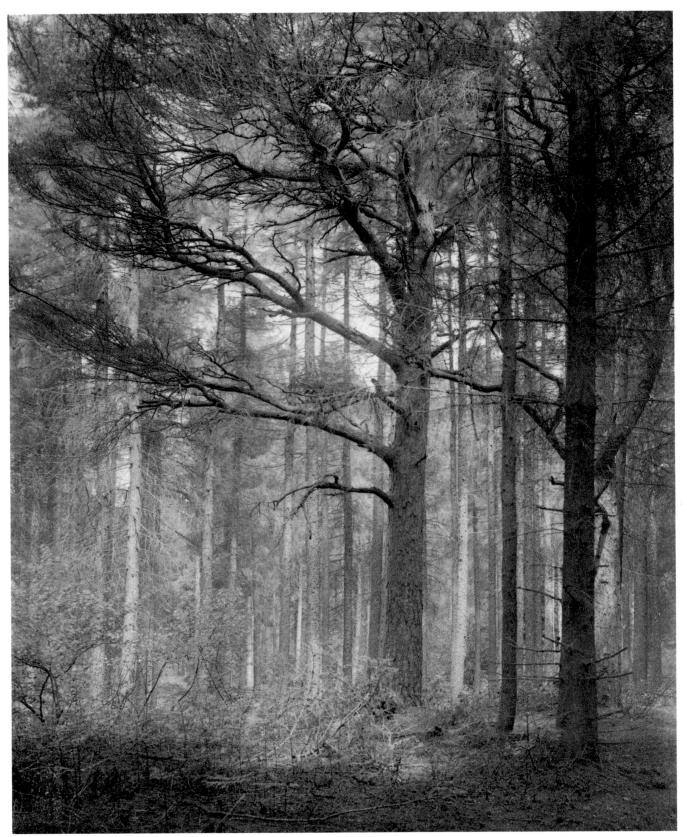

In Redlands Woods: Surrey

Therefore am I still
A lover of the meadows and the woods,
And mountains; and of all that we behold
From this green earth; of all the mighty world
Of eye, and ear,—both what they half create,
And what perceive; well pleased to recognize
In nature and the language of the sense
The anchor of my purest thoughts....

William Wordsworth,
Lines composed a few miles above Tintern Abbey.

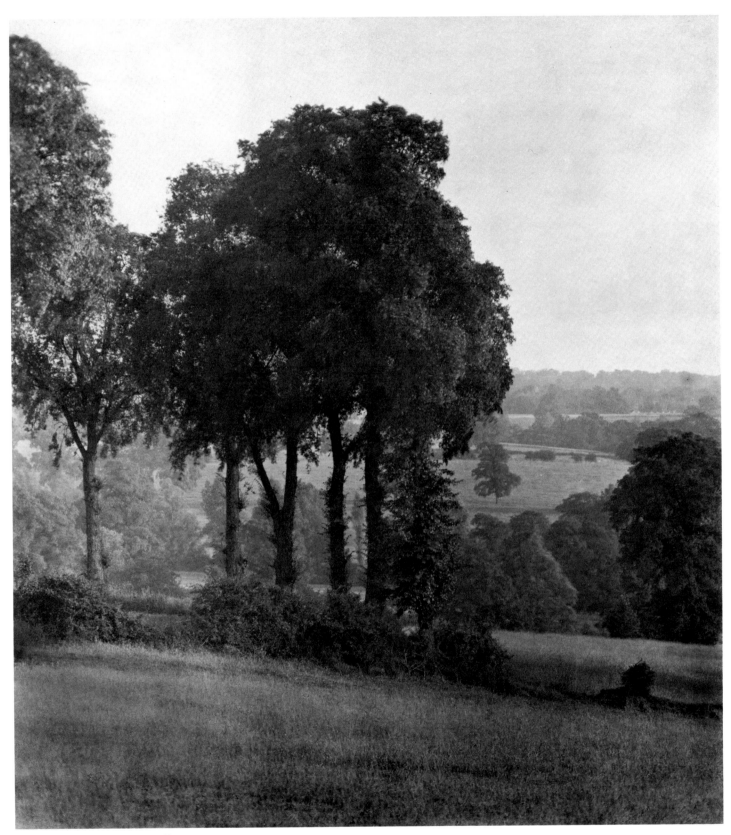

From Our Garden at Takeleys: Epping

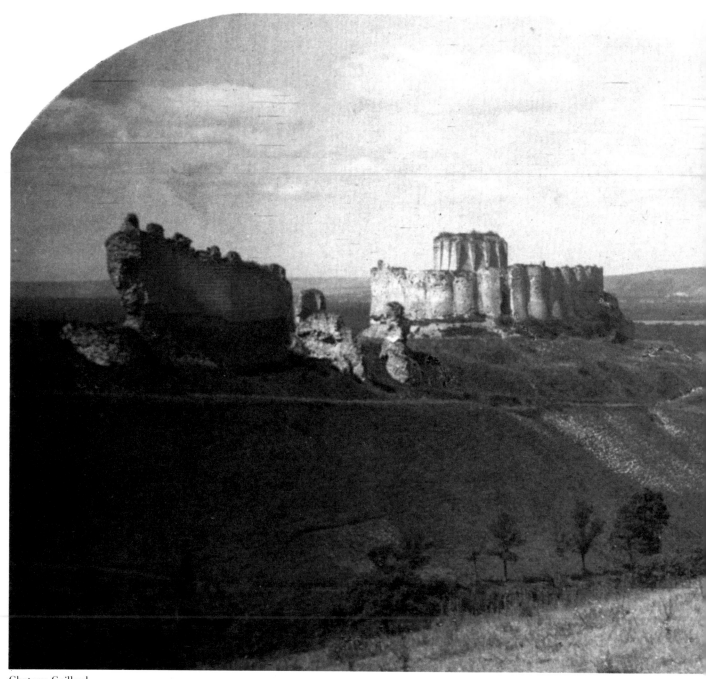

Chateau Gaillard

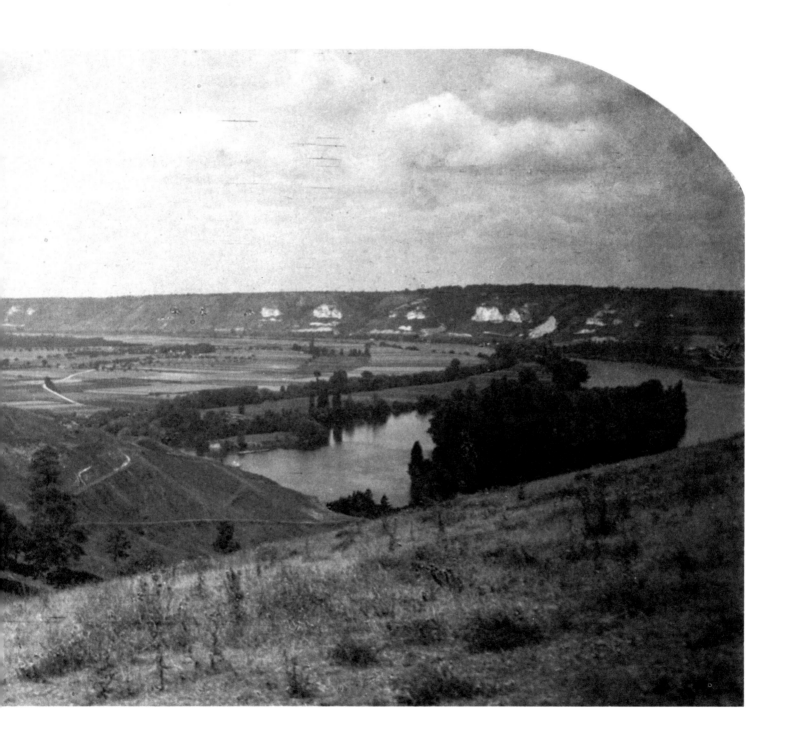

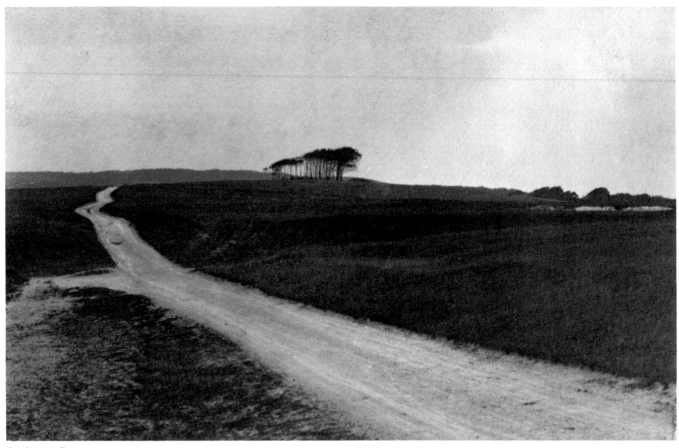

On Sussex Downs

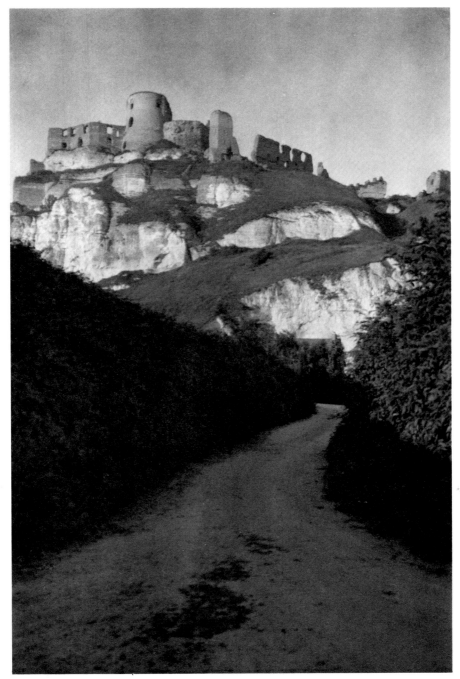

Chateau Gaillard

A quella luce cotal si diventa,
che volgersi da lei per altro aspetto
è impossibil che mai si consenta;
però che il ben, ch'è del volere obbietto,
tutto s'accoglie in lei; e fuor di quella
e difettivo ciò ch'e lì perfetto.

In that Light one becomes
such that it is impossible he
should ever consent to turn
himself from it for other sight;
because the Good which is the object
of the will is all collected in it,
and outside of it that is defective
which is perfect there.

Dante, *Paradiso, Canto 33*

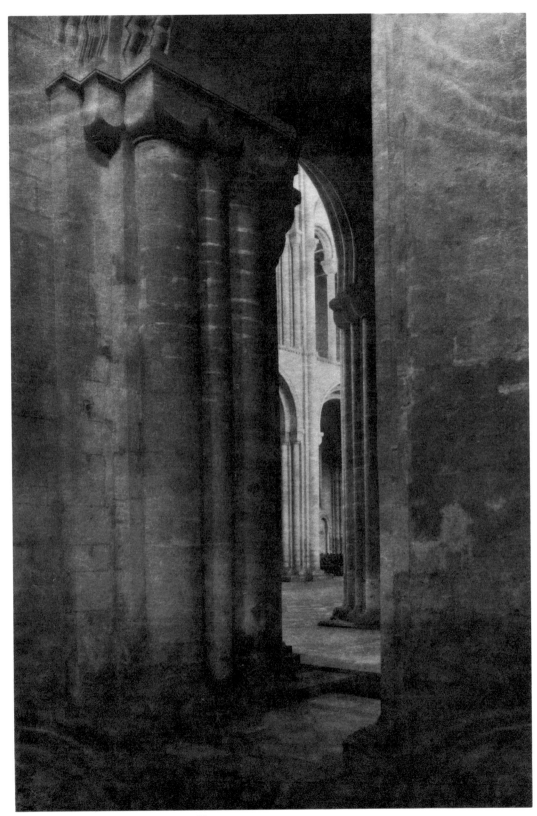

Ely Cathedral: Southwest Transept to Nave

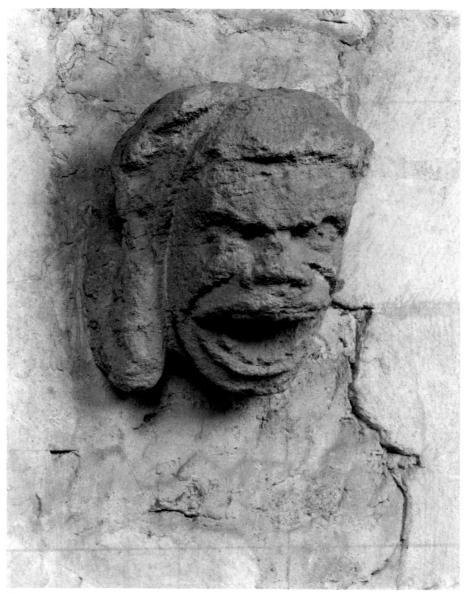

Ely Cathedral: Grotesque Sculpture in Triforium

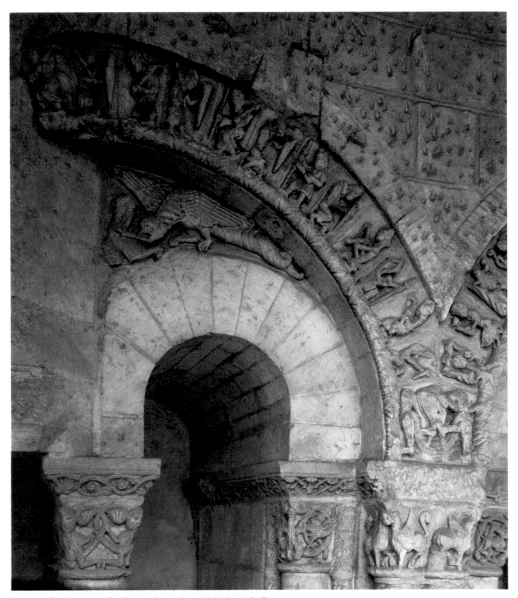

Angers: Prefecture, Sculptured arches of 11th-12th Century

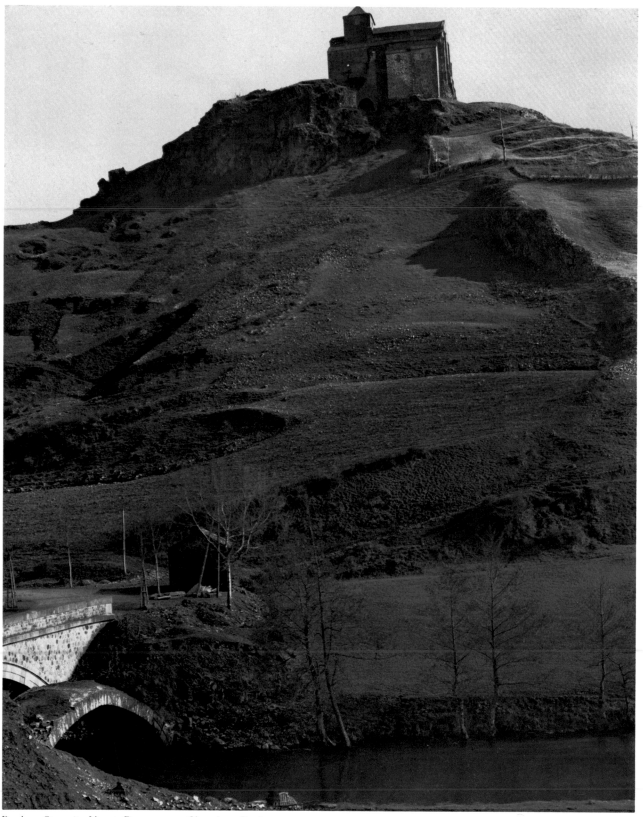

Bredons-Opposite Murat: Romanesque Church on Rock

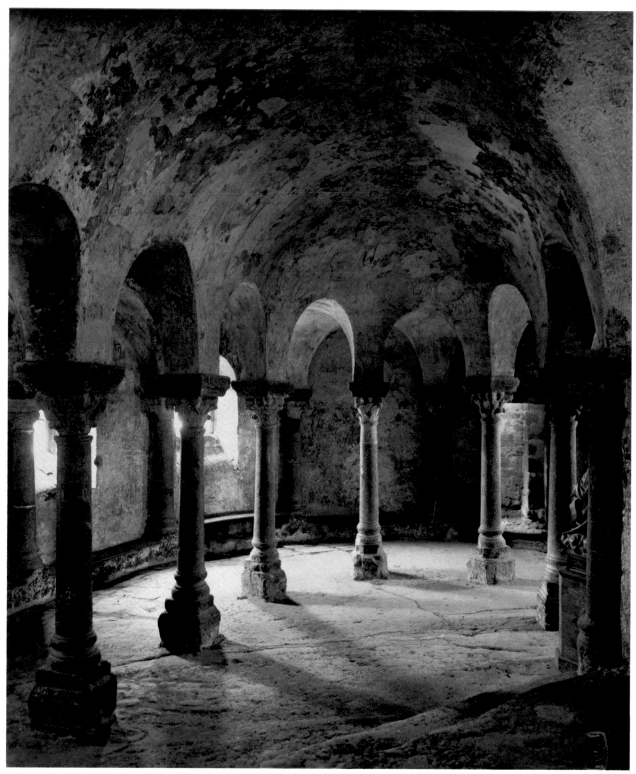

Le Puy—St. Michael's: From the Altar

THE SEA OF STEPS

. . . . The beautiful curve of the
steps on the right is for
all the world like the surge
of a great wave that will presently
break and subside into smaller ones like
those at the top of the picture. It is
one of the most imaginative lines
it has been my good fortune
to try and depict, this superb
mounting of the steps. . . .

Frederick H. Evans, 1903

While I thought I was climbing,
I found myself descending,
Having lost my way.
Let me go up and down,
I have no other work to do.

Early Christian Hymn

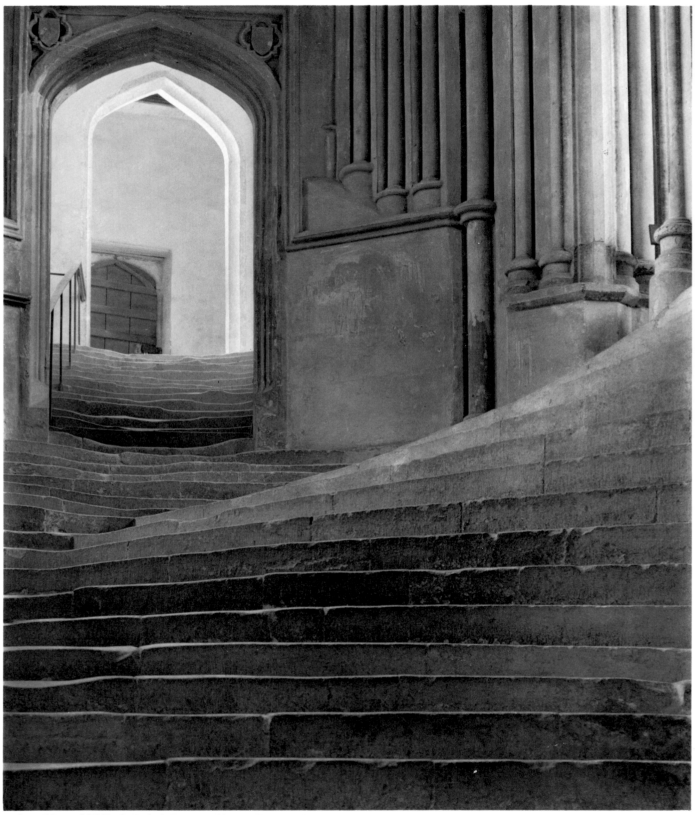

"A Sea of Steps," Wells Cathedral: Stairs to Chapter House and Bridge to Vicar's Close

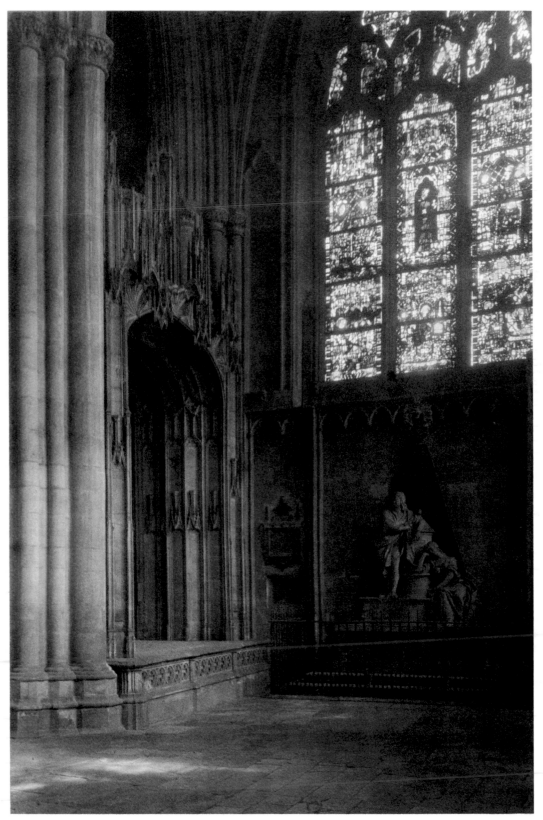

York Minster: East End Choir Aisle

"Enter These Enchanted Woods," George Meredith

Ada Evans

Redlands Woods

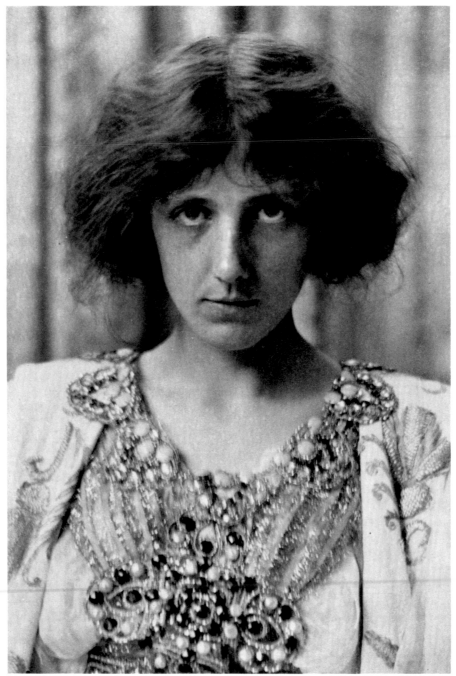

Ethel Wheeler

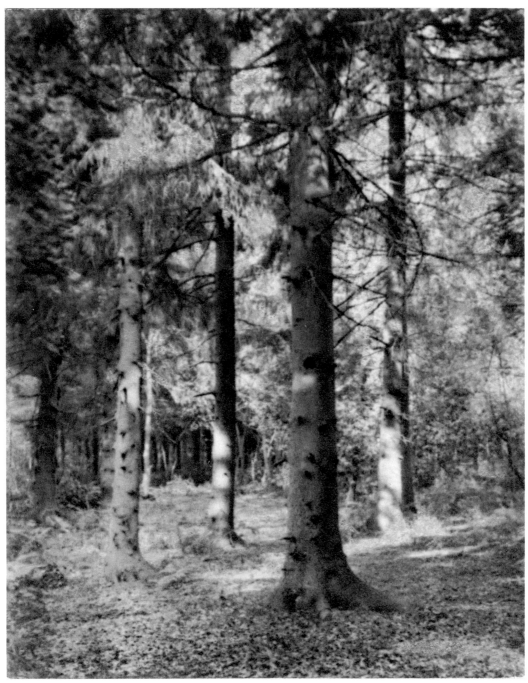

In Redlands Woods

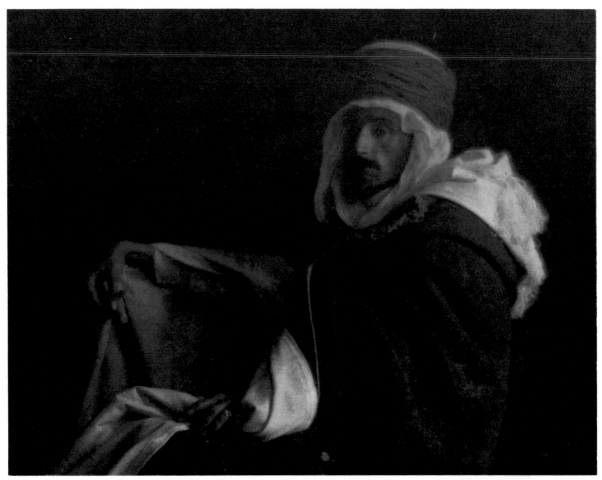

F. H. Day in Arab Costume, ca. 1901

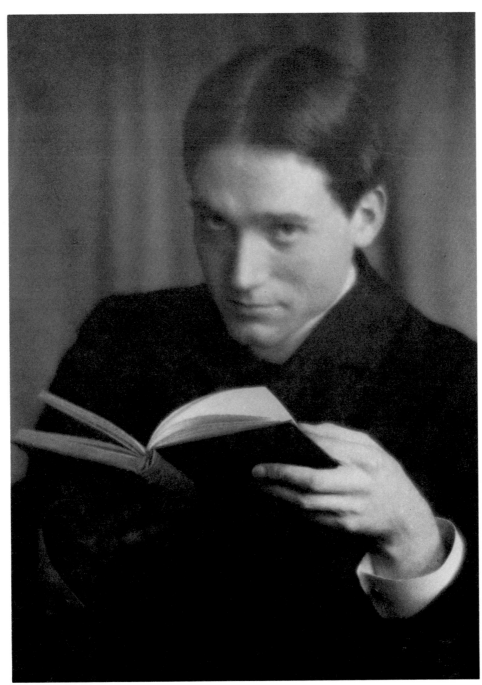

A. Granville Barker

In the Woods has many interests.
It shows how Mr. Evans' work will bear
the test of time, for it is one of those
woodland subjects that delighted
a few favored audiences in the
years long ago, before the Salon
came into being. It is an example of
fine technique, for the negative has been
lost, and the present reproduction is
from a print from a negative made by
copying a small platinotype of some
fifteen years ago. And it is a token of Mr.
Evans' appreciation of George Meredith,
for the particular print from which our
reproduction is made was printed for the
poet only just before his death [in 1909]
prevented his acceptance of it. It was to
illustrate his words from "In the Woods,"
in *The Fortnightly Review:*

A wind sways the pines,
And below
Not a breath of wild air:
All still as the mosses that glow
On the flooring and over the lines
Of the roots here and there.
The pine-tree drops its dead:
They are quiet as under the sea.
Overhead, overhead,
Rushes life in a race,
As the clouds the clouds chase:
And we go,
And we drop like the fruits of the tree,
Even we,
Even so.

Photograms . . . 1909, p. 47

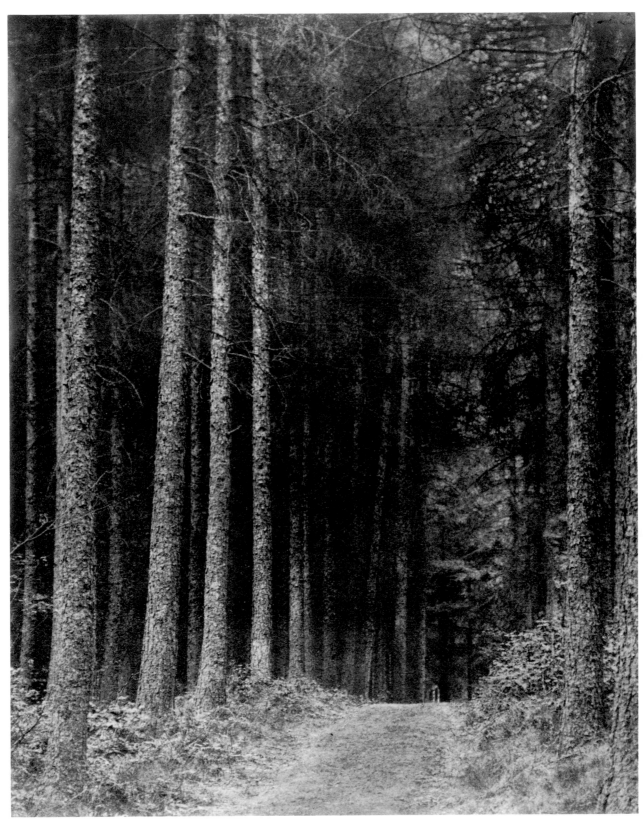

In Redlands Woods: Holmwood: by Dorking

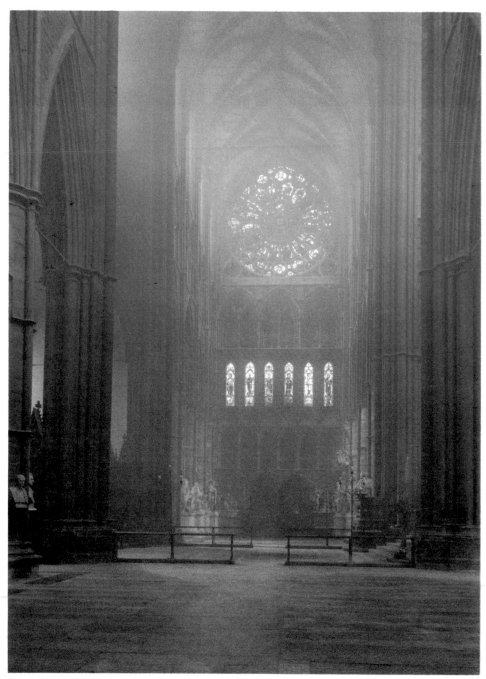

Westminster Abbey: Across the Transepts

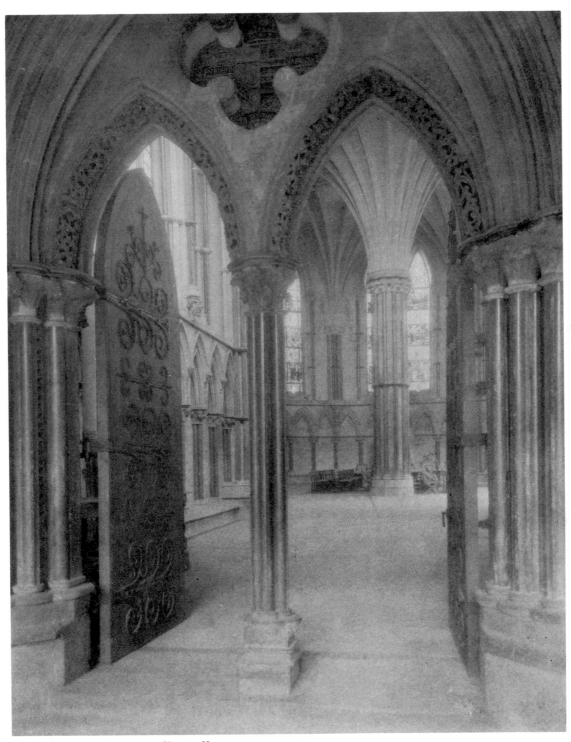

Lincoln Cathedral: Entrance to Chapter House

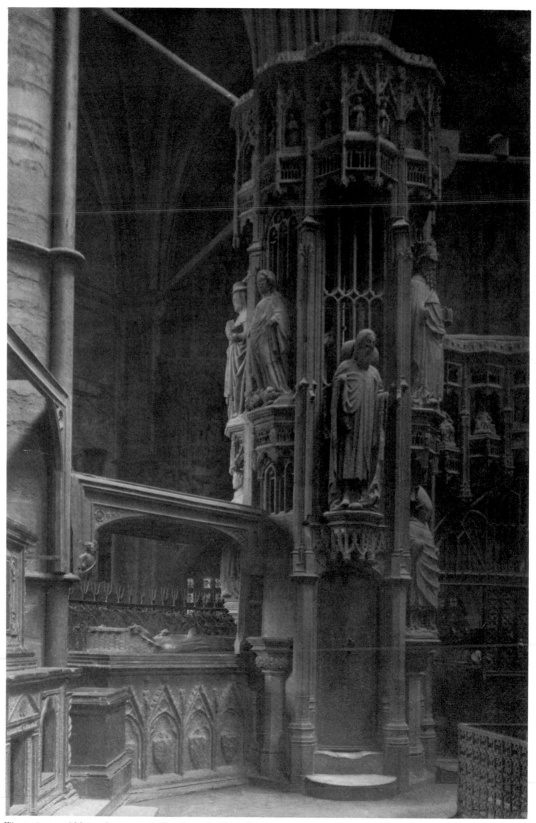

Westminster Abbey: Stairway in Confessor's Chapel

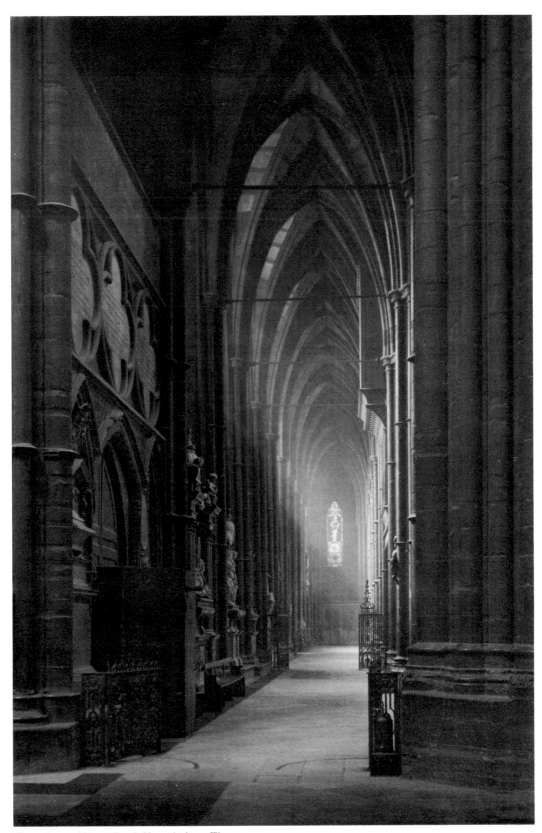

Westminster Abbey: South Nave Aisle to West

ANTIPHON

Cho. Let all the world in ev'ry corner sing.
　　　　　　　　　　My God and King.

　Vers. The heav'ns are not too high,
　　　　His praise may thither fly:
　　　　The earth is not too low,
　　　　His praises there may grow.

Cho. Let all the world in ev'ry corner sing,
　　　　　　　　　　My God and King.

　Vers. The church with psalms must shout,
　　　　No door can keep them out:
　　　　But above all, the heart
　　　　Must bear the longest part.

Cho. Let all the world in ev'ry corner sing,
　　　　　　　　　　My God and King.

George Herbert

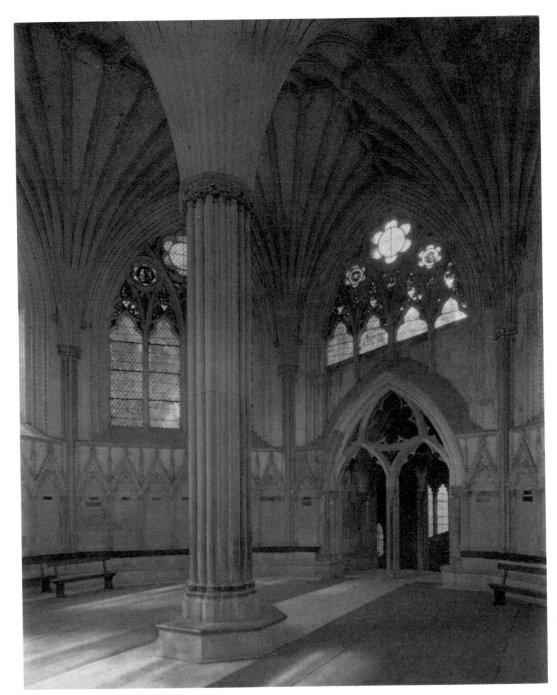

Wells Cathedral: South Nave Aisle to West

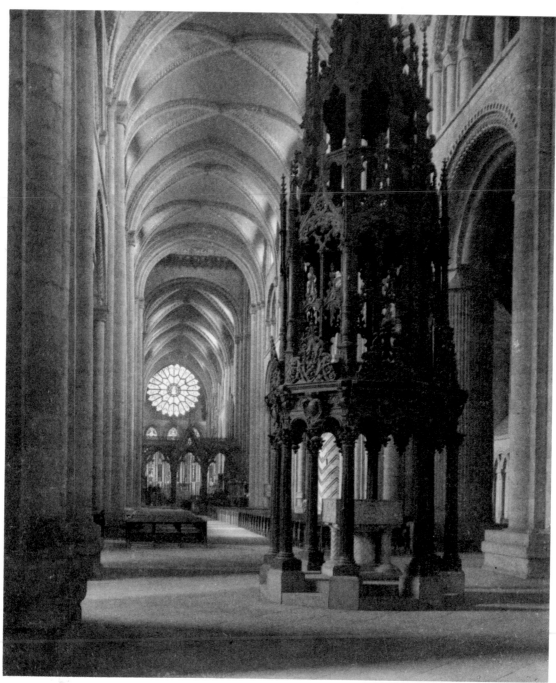

Durham Cathedral

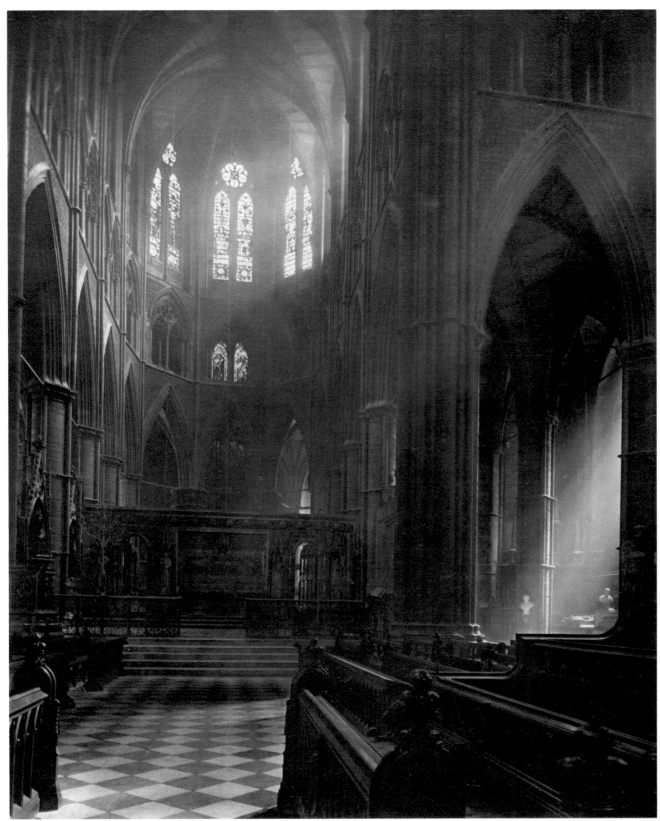

Gloucester Cathedral: The Cloisters

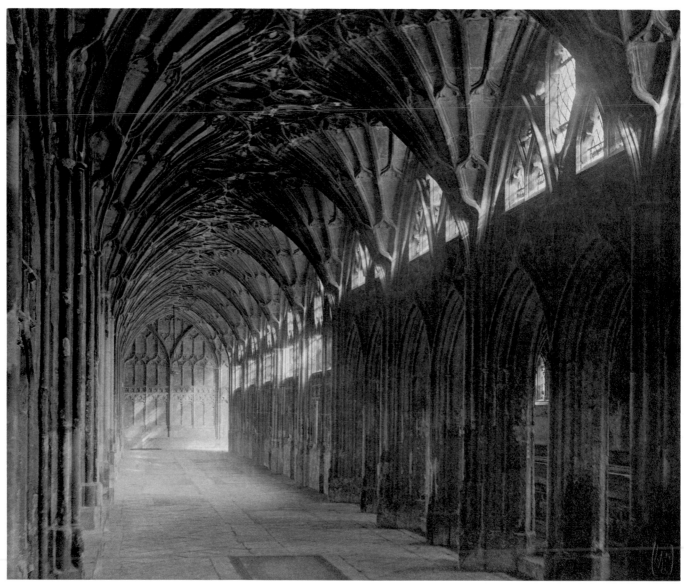

Westminster Abbey: Apse from Choir

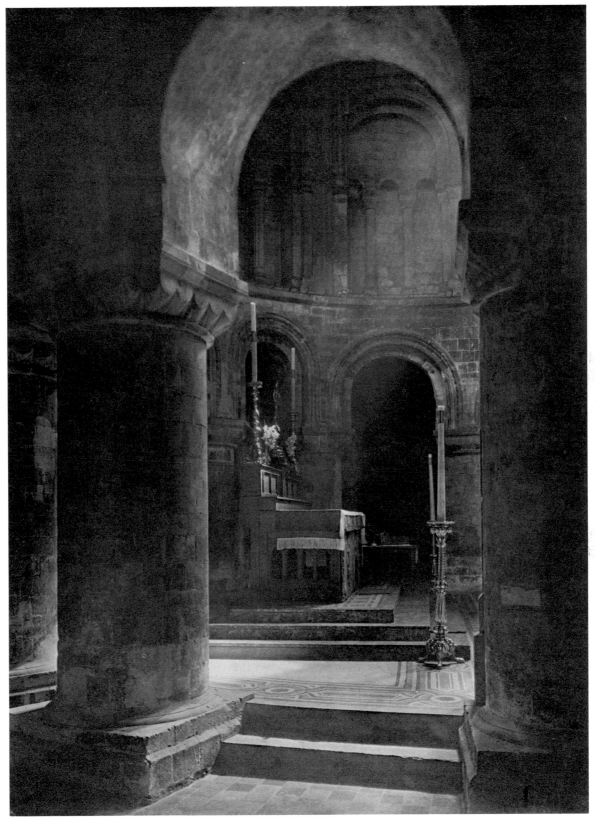

Priory of St. Bartholomew the Great, Smithfield

IN SURE AND CERTAIN HOPE

This subject fascinated but troubled me.
I at once saw the making of a picture in it;
the great somber door that might open
and lead—anywhere; the fortunately
placed recumbent figure with the pathos
of uplifted folded hands; the lofty
window above; all these were fine and right;
but to make the whole cohere, speak,
escaped me. But one day I saw what
it must mean—to me at least.
As I was studying it the sun burst
across it, flooding it with radiance.
There is my picture; "Hope" awaiting,
an expectancy with a certitude of answer;
and the title seemed defensible,
if a little ambitious.

Frederick H. Evans in *Camera Work, No. 4*

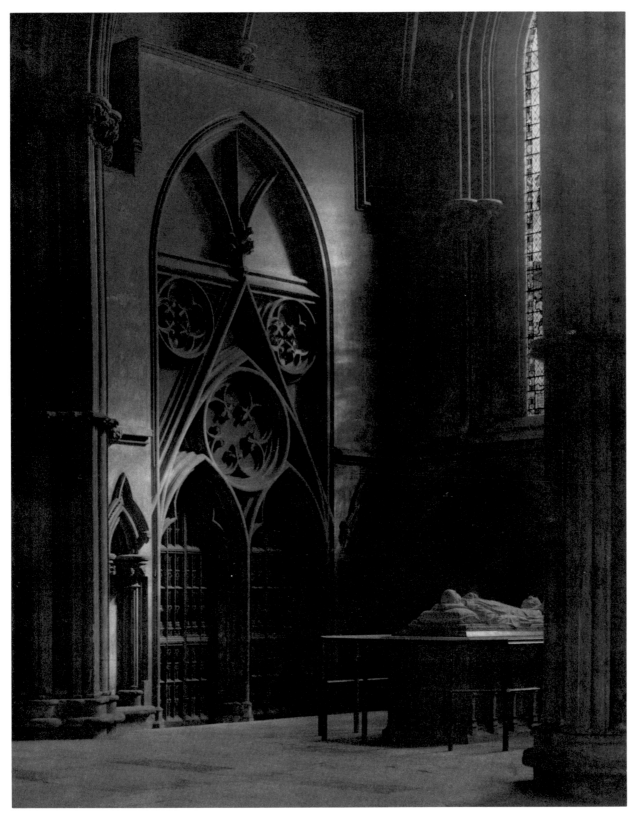

"In Sure and Certain Hope," York Minster, 1902

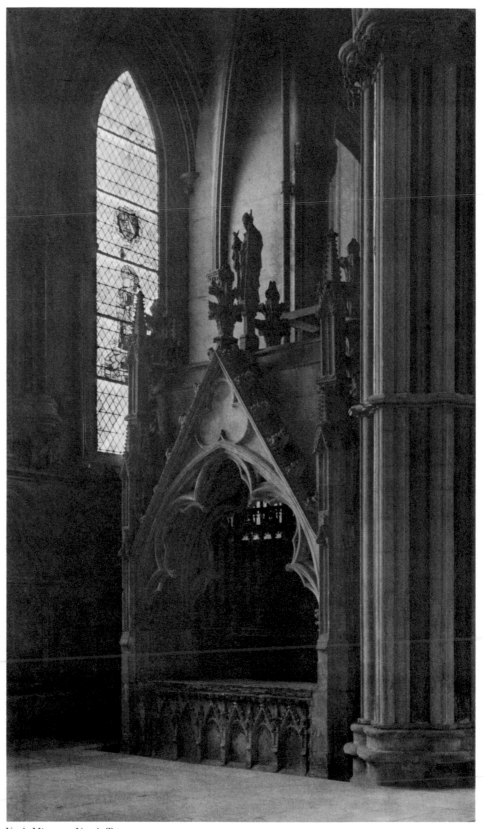

York Minster: North Transept

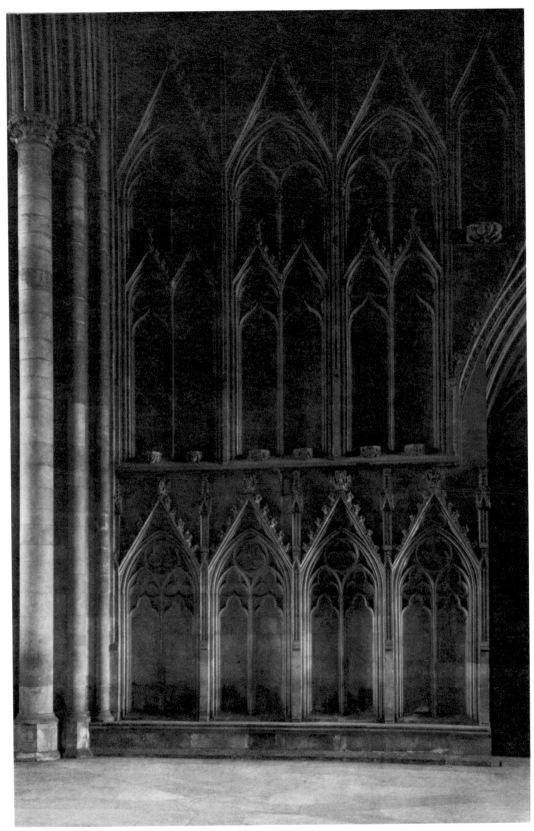

York Minster: West End Nave

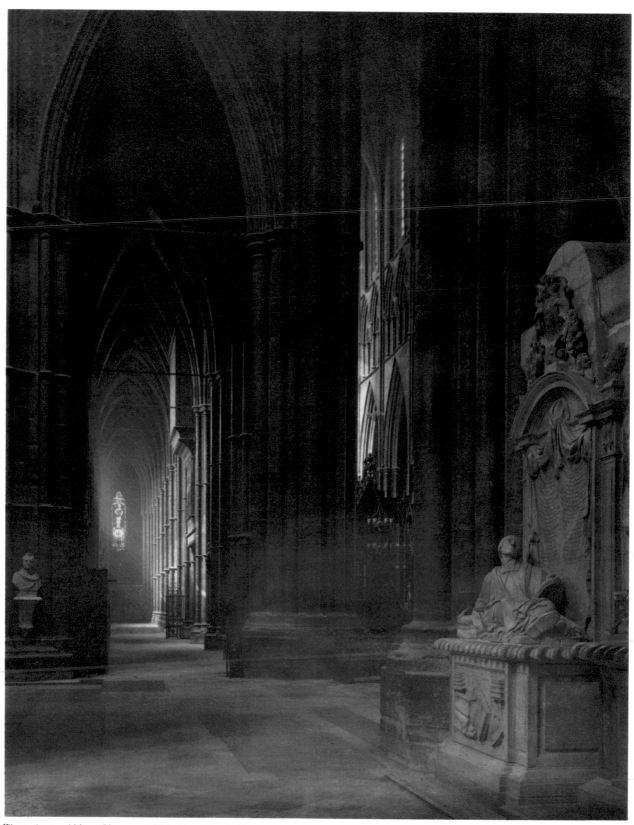

Westminster Abbey: Nave and Aisle From South Transept

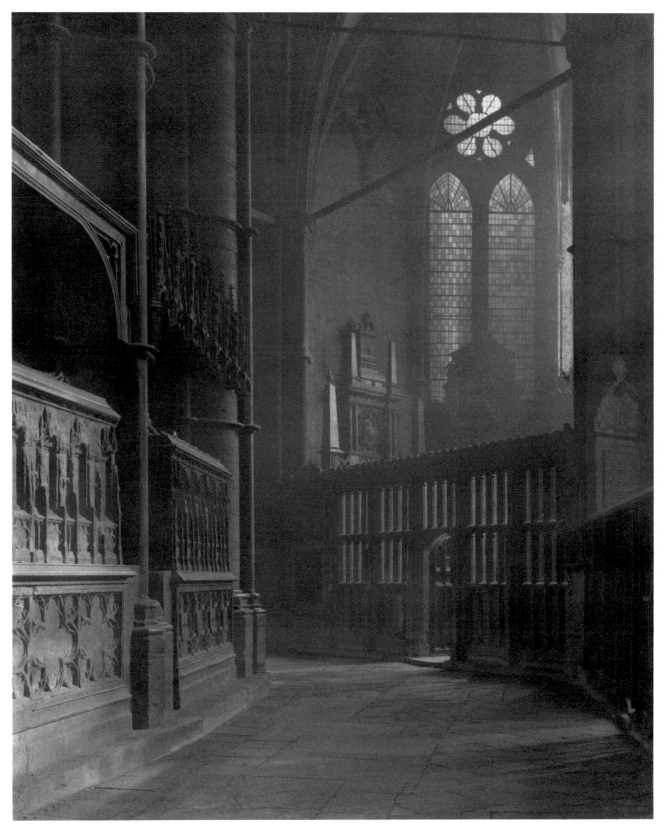

Westminister Abbey: South Ambulatory, Chapel of St. Nicholas

Westminster Abbey: Detail of Henry VII Tomb

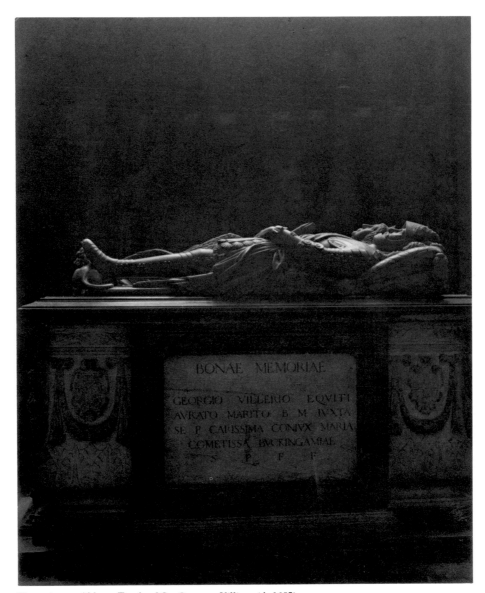

Westminster Abbey: Tomb of St. Georges Villiers (d. 1605)

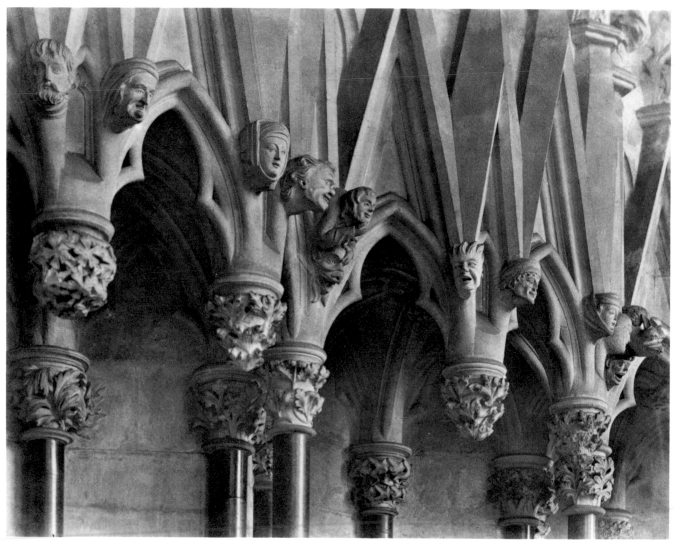

York Minster: Chapter House Sculpture

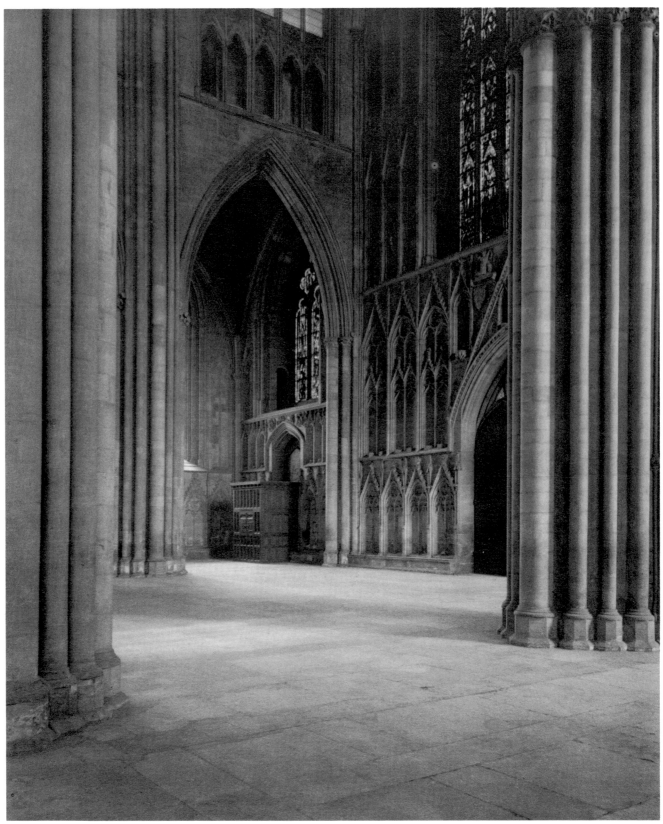

York Minster: West End of Nave

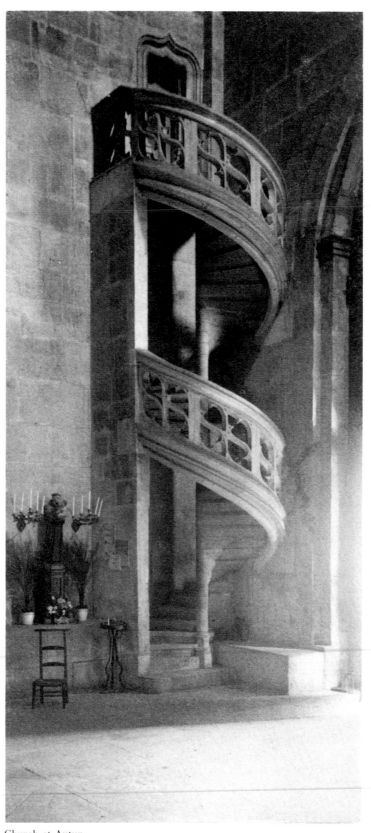

Church at Autun

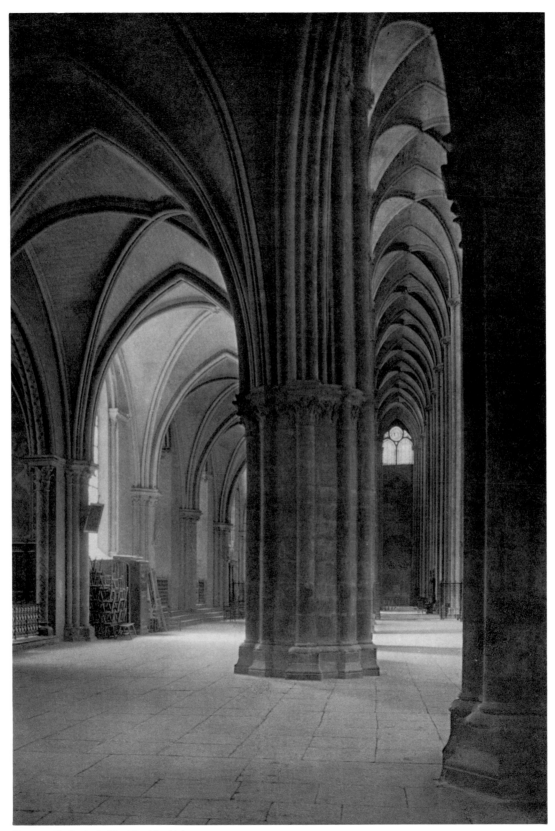

Bourges Cathedral: The Double Aisles

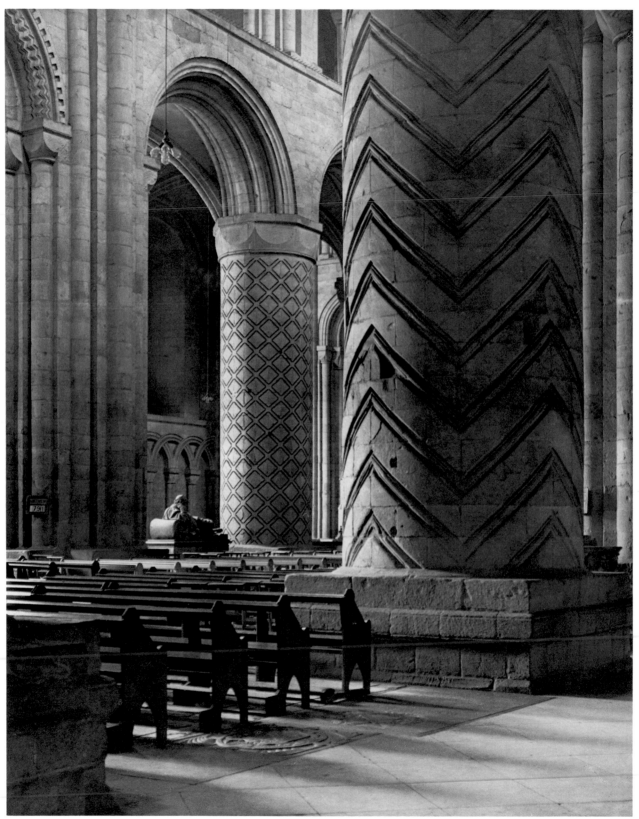

Durham Cathedral: Across Nave from South Aisle

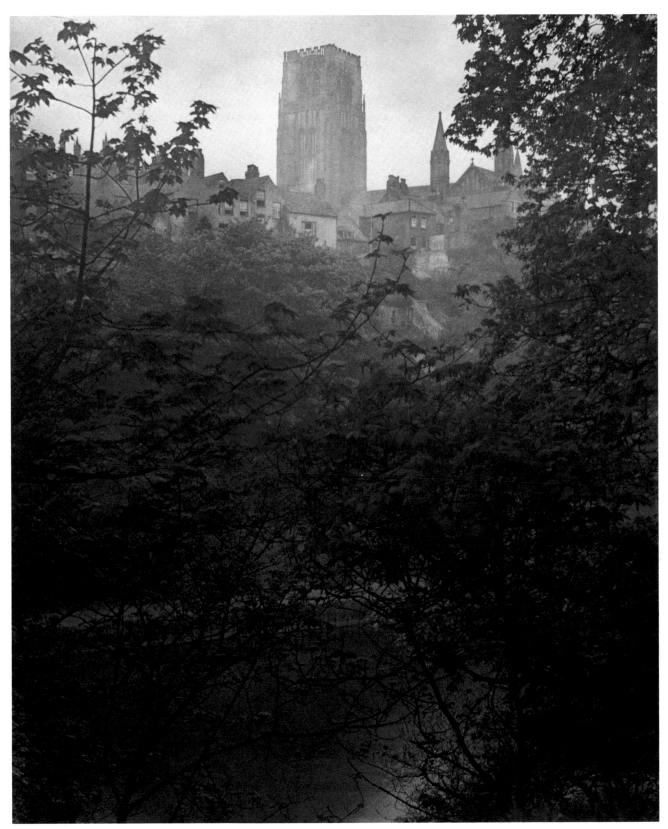

Durham Cathedral

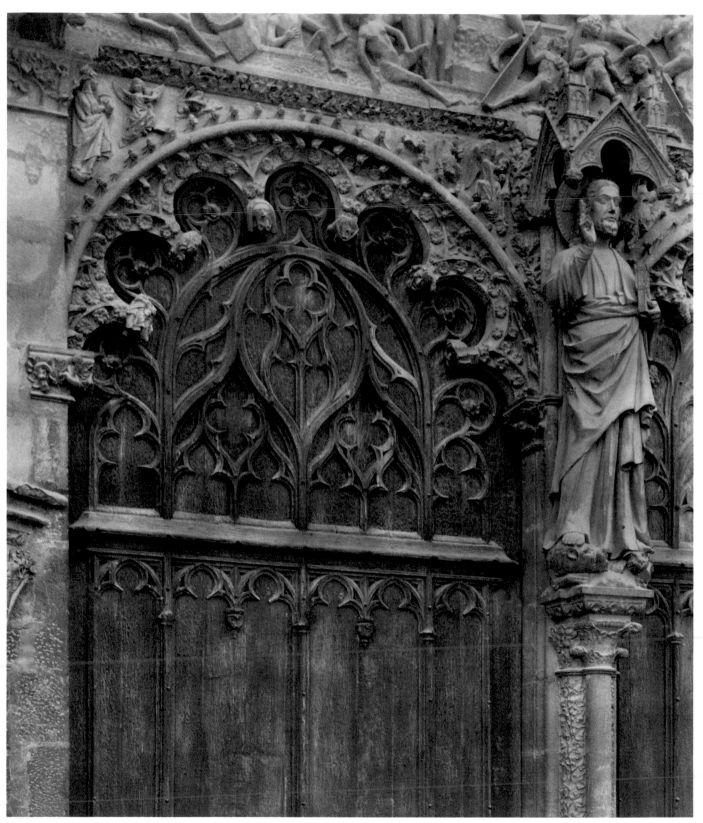

Bourges Cathedral: Crypt Under Nave

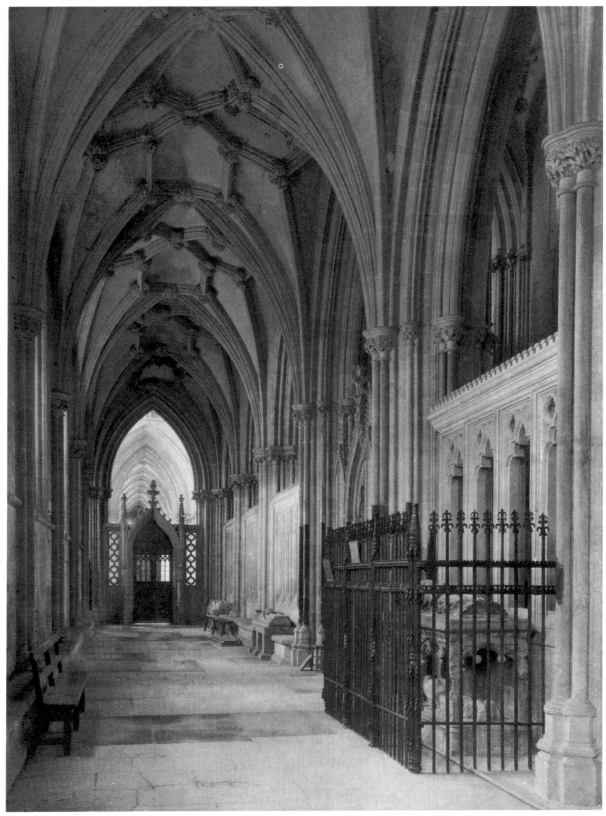

Wells Cathedral: South Choir Aisle to West

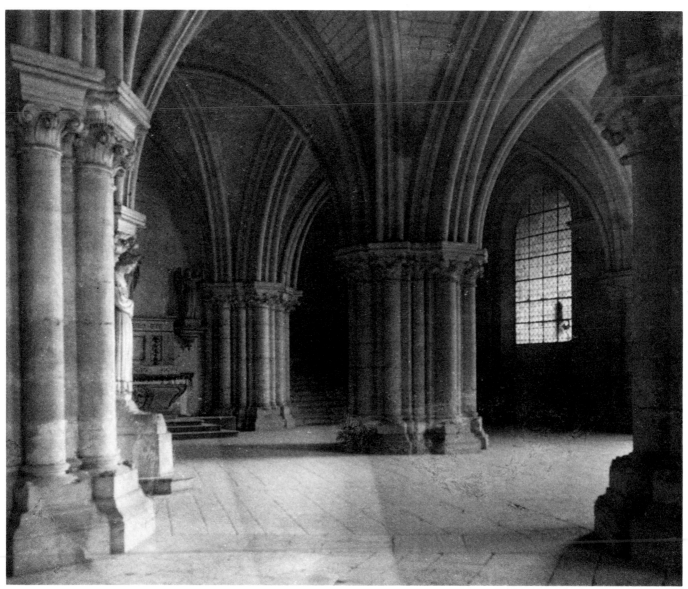

Bourges Cathedral

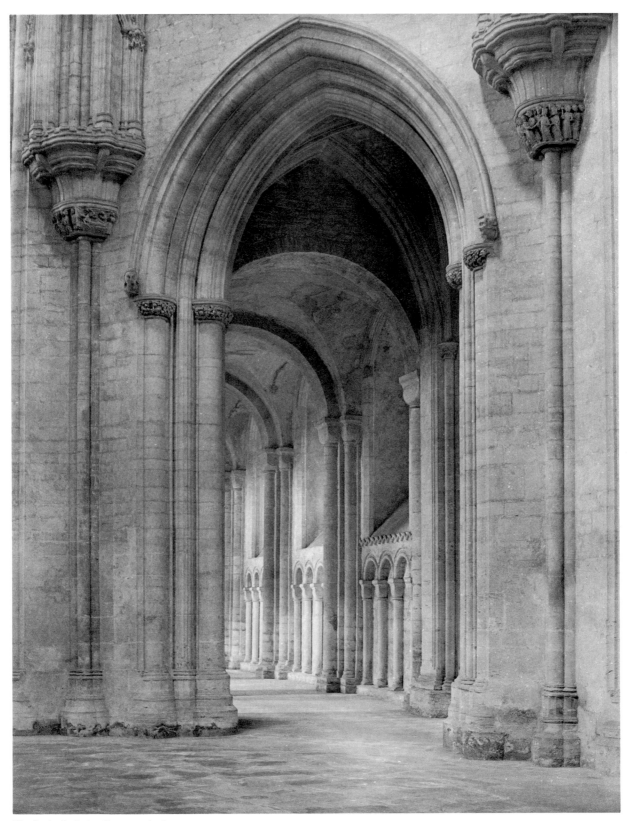

Ely Cathedral: An Octagon Arch

NOTES AND BIBLIOGRAPHY

ABBREVIATIONS OF PERIODICALS

Amat. Phot. The Amateur Photographer, London
Amer. Amat. Phot. The American Amateur Photographer, New York
Brit. Jour. Phot. The British Journal of Photography, London
Phot. Photography, London
Phot. Jour. The Photographic Journal
Phot. News. The Photographic News, London

SOURCES OF QUOTATIONS

1. *Camera Work*, No. 4, Oct., 1903, p. 13–14.
2. Anderson Galleries, New York, *Forty-three Original Drawings by Aubrey Beardsley; the Collection of Frederick H. Evans of London*, Mar. 20, 1919, p. 5.
3. *Phot. Jour.*, Dec. 31, 1886, p. 22.
4. *Brit. Jour. Phot.*, Jan. 8, 1886, p. 20–21.
5. *Amat. Phot.*, Feb. 11, 1908, p. 129–30.
6. *Phot. Jour.*, Feb., 1945, p. 36.
7. *Amat. Phot.*, May 12, 1904, p. 372
8. *Photograms of the Year 1903*, p. 22.
9. *Amat. Phot.*, Mar. 31, 1904, p. 253.
10. *Photograms of the Year 1903*, p. 20.
11. *Amat. Phot.*, Feb. 4, 1904, p. 83.
12. *Boston Evening Transcript*, Feb. 21, 1903.
13. *Amat. Phot.*, Aug. 17, 1909, p. 160.
14. *Camera Work*, No. 4, Oct., 1903, p. 17.
15. *Phot. Jour.*, p. 101–102.
16. *Phot. Jour.*, Apr. 30, 1900, p. 239.
17. *Phot. News*, Jan. 26, 1906, p. 78.
18. *Phot. News*, Apr. 5, 1907, p. 275.
19. *Amat. Phot.*, Mar. 7, 1905, p. 197.
20. *Phot. Jour.*, Apr. 30, 1900, p. 238–39.
21. *Photograms of the Year 1900*, p. 73–74.
22. *Image*, Dec., 1953, p. 59.
23. *Phot.*, Jul. 2, 1907, p. 2
24. *Amat. Phot.*, Oct. 2, 1902, p. 271.
25. *Ibid.*, p. 273.
26. Autograph letter, F. H. Evans to Alfred Stieglitz, Aug. 22, 1904. (Stieglitz Archives, Yale University.)
27. *Phot. Jour.*, Feb., 1908, p. 99–114.
28. Autograph letter, F. H. Evans to Alfred Stieglitz, June 18, 1903. (Stieglitz Archives, Yale University.)
29. F. H. E. to A. S., Jul. 23, 1903 (Stieglitz Archives, Yale University.)
30. *Camera Work*, No. 4, Oct. 1903, p. 25.
31. *Ibid.*, p. 15.
32. *Amat. Phot.*, Oct. 11, 1901, p. 283
33. *Ibid.*, p. 304.
34. *Phot.*, Oct. 10, 1903, p. 306.
35. *Camera Work*, No. 4, Oct., 1903, p. 21.
36. *Camera Work*, No. 8, Oct., 1904, p. 44.
37. *Amat. Phot.*, Jun. 11, 1903, p. 476–78.
38. *Amat. Phot.*, Jun. 25, 1903, p. 508.
39. *Amat. Phot.*, Jul. 9, 1903, p. 23.
40. *Camera Work*, No. 16, Oct., 1906, p. 23.
41. *Amat. Phot.*, Nov. 12, 1903, p. 390.
42. *Amat. Phot.*, Jan. 29, 1907, p. 92. Transl. from *Revue de Photographie*, 4ᵉ année, 1906, p. 353–57.
43. *Amat. Phot.*, Jan. 29, 1907, p. 94.
44. *Ibid.*, p. 94–95.
45. *Ibid.*, p. 92.
46. *Phot. Jour.*, Feb., 1945, p. 31.
47. *Amat. Phot.*, Dec. 6, 1904, p. 455.
48. *Amat. Phot.* Mar. 6, 1911, p. 220.
49. *Amer. Amat. Phot.*, Mar., 1906, p. 102.
50. Autograph letter, F. H. Evans to Alfred Stieglitz, Nov. 11, 1906. (Stieglitz Archives, Yale University.)
51. F. H. E. to A. S., Nov. 9, 1905. (Stieglitz Archives, Yale University.)
52. *Photograms of the Year 1900*, p. 24.
53. *Amat. Phot.*, Oct. 1, 1907, p. 325.
54. *Phot.*, Sep. 24, 1907, p. 258.
55. *Phot.*, Sep. 15, 1908, p. 384.
56. *Photograms of the Year 1908*, p. 64.
57. Autograph letter, F. H. Evans to Alfred Stieglitz, Dec. 6, 1908. (Stieglitz Archives, Yale University.)
58. *Amat. Phot.*, Jul. 21, 1904, p. 43.
59. *Amat. Phot.*, Jul. 13, 1909, p. 48.
60. *Amat. Phot.*, Jul. 20, 1909, p. 89.
61. *Camera Work*, No. 25, Jan., 1909, p. 35.
62. *Phot.*, May 11, 1909, p. 377.
63. *Amat. Phot.*, Sep. 21, 1909, p. 293–95.
64. *Ibid.*
65. *Phot.*, Oct. 26, 1909, p. 336.
66. *Phot.*, Aug. 30, 1910, p. 172.
67. *Phot.*, Sep. 27, 1910, p. 225.
68. Autograph letter, F. H. Evans to Alfred Stieglitz, Dec. 1, 1910. (Stieglitz Archives.)

69. *Camera Work*, No. 5, Jan., 1904, p. 29.
70. Autograph letter, F. H. Evans to Alfred Stieglitz, Apr. 12, 1915. (Stieglitz Archives, Yale University.)
71. *Amat. Phot.*, Jul. 7, 1908, p. 5–6.
72. Autograph letter, F. H. Evans to Alfred Stieglitz, Jan. 29, 1911. (Stieglitz Archives, Yale University.)
73. F. H. E. to A. S., Apr. 12, 1915. (Stieglitz Archives, Yale University.)
74. *Brit. Jour. Phot.*, Mar. 2, 1917, p. 115.
75. *Brit. Jour. Phot.*, Mar. 9, 1917, p. 126.
76. *Brit. Jour. Phot.*, Mar. 16, 1917, p. 142–43.
77. *Brit. Jour. Phot.*, Mar. 23, 1917, p. 155.
78. *The Saturday Book*, London, 1943, p. 162.
79. *Phot. Jour.*, Feb., 1945, p. 35.

ARTICLES ABOUT FREDERICK H. EVANS

[Bayley, R. Child.] The Ideas and Methods of Mr. Frederick H. Evans. *Phot.*, Jan. 2, 1902, p. 1–5 Unsigned; presumably by the editor.

B. H. The Portraits of Prominent Photographers Limned from Life. IV.—Frederick H. Evans. *Phot.*, Jul. 2, 1907, p. 2.

Coburn, Alvin Langdon. Frederick H. Evans. *Image*, Dec., 1953, p. 58–59.

Hinton, A. H. Artistic Photography Today: Mr. Frederick H. Evans. *Amat. Phot.*, Nov. 8, 1904, p. 367–69. Reprinted from *The Magazine of Art*, 1904, p. 372–77.

In Praise of Frederick H. Evans: A Symposium. *Phot. Jour.*, Feb., 1945, p. 25–38. Reminiscences by J. Dudley Johnston, Charles Emanuel, Malcolm Arbuthnot, Alvin Langdon Coburn, Herbert Felton, J. R. H. Weaver; reprint from *Camera Work* of G. B. Shaw appreciation.

Johnston, J. Dudley. Memorial Exhibition of Photographs by Fredk. H. Evans, Hon. F.R.P.S. *Phot. Jour.*, Nov., 1944, p. 328.

Lambert, F. C. The Pictorial Work of Frederick H. Evans. *The Practical Photographer* (Library Series), No. 5 [1903], p. 1–5.

Shaw, George Bernard. Evans—An Appreciation. *Camera Work*, No. 4, Oct., 1903, p. 13–16. Reprinted in *Phot. Jour.*, Feb., 1945, p. 32–33; *Phot.*, Dec., 1961, p. 27–28, 33.

Strasser, Alex. Evans, Photographer. *The Saturday Book*, London, 1943, p. 149–64.

"Touchstone." Photographers I Have Met: No.

8—Frederick H. Evans. *Amat. Phot.*, Jul. 20, 1909, p. 71.

Weaver, J. R. H. The Late Frederick H. Evans, Hon. F.R.P.S. *Phot. Jour.*, Aug., 1943, p. 295.

ARTICLES BY FREDERICK H. EVANS

Photo-Micrography. *Phot. Jour.*, Dec. 31, 1886, p. 25–28.

Lenses in Sets for Landscape Work. *Int'l Annual of Anthony's Photo. Bul.* 1888, p. 183–85.

Lincoln Cathedral, *Phot. Jour.*, Dec. 23, 1899, p. 101–105.

Tinkering with Developer. *Phot.*, Jan. 11, 1900, p. 31.

Telephoto v. Ordinary Lenses. *Phot.*, Jan. 18, 1900, p. 52.

Opening Address at Royal Photographic Society Exhibition, *Phot. Jour.*, Apr. 30, 1900, p. 236–41.

Good Drawing in Photography. *Phot.*, May 10, 1900, p. 318.

"The Exhibition of American Photography at Russell Square," *Brit. Jour. Phot.*, Oct. 26, 1900, p. 677–78.

Shop and Other Portraiture. *Amat. Phot.*, Nov. 6, 1902, p. 370–71.

Time Development and the Kodak Development Machine. *Amat. Phot.*, Dec. 18, 1902, p. 499.

Wanted, A Plate. *Phot.*, Dec. 20, 1902, p. 871.

Camera-Work in Cathedral Architecture. *Camera Work*, No. 4, Oct., 1903, p. 17–21.

And What Went Ye Out for to See? *Photograms of the Year 1903*, p. 18–24.

Artistic Photography in Lantern Slides. *Amat. Phot.*, Feb. 19, 1903, p. 148–49.

The Exhibiting of Lantern Slides. *Amat. Phot.*, Mar. 5, 1903, p. 192.

Mr. H. W. Bennett on Mechanical Development: A Criticism. *Amat. Phot.*, Apr. 23, 1903, p. 336.

Tithe Barn at Great Cokkeswell, Berks. *Amat. Phot.*, May 21, 1903, p. 413.

Imitation: Is It Necessary or Worth While? *Amat. Phot.*, June 11, 1903, p. 475.

Wells Cathedral. *Phot.*, Jul. 18, 1903, p. 65–67.

Cloisters of Gloucester Cathedral. *Phot.*, Aug. 22, 1903, p. 162.

The Salon of the R.P.S. Loan Collection. *Phot.*, Aug. 29, 1903, p. 180.

Notes on Some Landscapes at the Salon. *Amat. Phot.*, Oct. 8, 1903, p. 285.

Notes on Three Examples of the Work of Robert Demachy. *Amat. Phot.*, Nov. 12, 1903, p. 390.

Short Walk in Gloucester Cathedral. *Phot.*, Dec. 26, 1903, p. 536.

Odds & Ends. *Camera Work*, No. 5, Jan., 1904, p. 25–30.

Mounting the Exhibition Print. *The Photogram*, Jan.–Dec. 1904. A series of monthly articles.

The Cult of Vagueness. *Amat. Phot.*, Feb. 4, 1904, p. 83.

Painters and Photographers. *Phot.*, Feb. 13, 1904, p. 125, A letter.

Technical Ideals, *Amat. Phot.*, Mar. 17, 1904, p. 202.

Notes on "An Open Door." *Amat. Phot.*, Mar. 31, 1904, p. 253–55.

Some Notes on Interior Work. *Amat. Phot.*, Apr. 7–May 12, 1904. A series of six articles.

Jottings at the Royal Academy. *Amat. Phot.*, June 16, 1904, p. 479–80; June 23, 1904, p. 500–501.

No One Is Ever the Worse for Knowing. *Amat. Phot.*, June 30, 1904, p. 506.

Pros and Cons. *Camera Work*, No. 7, Jul., 1904, p. 25–29.

A Plea with the Manufacturer for an Artist's Pocket Camera. *Amat. Phot.*, Jul. 28, 1904, p. 71.

Exhibition of Photographs of Julia Margaret Cameron. *Amat. Phot.*, July 21, 1904, p. 43.

Internal Cohesion: A Society of Societies. *Amat. Phot.*, Aug. 25, 1904, p. 142.

Pictorial Pointers for Architectural Photographers. *Practical Phot.*, Sept., 1904, p. 47–50.

Pros & Cons. *Camera Work*, No. 8, Oct., 1904, p. 23–26.

The Correction of Over-Exposure. *Amat. Phot.*, Oct. 18, 1904, p. 308.

The Photographic Salon, London, 1904. *Camera Work*, No. 9, Jan., 1905, p. 37–47.

Birmingham Photographic Society's Exhibition. *Amat. Phot.*, Mar., 1905, p. 197.

Glass Versus Paper. *Camera Work*, No. 10, April, 1905, p. 36–41.

Hints on Landscape Work in English Lakeland. *Amat. Phot.*, May 9, 1905, p. 374.

Orthochromatic Renderings of Kodoid Films. *Amat. Phot.*, May 30, 1905, p. 434.

The London Photographic Salon for 1905, *Camera Work*, No. 13, Jan., 1906, p. 46–51.

A Pianola for a Musician and a Camera for an Artist. *Amat. Phot.*, Jan. 23, 1906, p. 75.

Lantern Slides and Their Optical Projection. *Phot.*, Feb. 20, 1906, p. 145–47; Feb. 27, 1906, p. 166–67; Mar. 6, 1906, p. 191–2.

Hand Camera of the Future. *Amat. Phot.*, Feb. 27, 1906, p. 171.

The London Photographic Salon for 1906. *Camera Work*, No. 17, Jan., 1907, p. 29–33.

F. H. Evans' Views [on Demachy Article]. *Amat. Phot.*, Jan. 29, 1907, p. 94. Reprinted, *Camera Work*, No. 18, 1907, p. 46–48.

Art in Photographs. *Amat. Phot.*, Feb 19, 1907, p. 139.

My Best Picture and Why I Think So. *Phot. News*, Apr. 5, 1907, p. 276.

What Is a "Straight Print"? *Amat. Phot.*, Jul. 30, 1907, p. 111.

Notes on Multiple Mounting. *Phot. Jour.*, Feb. 1908, p. 99. Partially reprinted in *Photographic Times*, July, 1908, p. 625.

Art in Monochrome. *Amat. Phot.*, Feb. 4, 1908, p. 106; Feb. 11, 1908, p. 129–30.

Some Notes on Print Mounting. *Phot. News*, Feb. 28, 1908, p. 199.

The Multiple Mounting of Prints. *Brit. Jour. Phot.*, Mar. 6, 1908, p. 178.

An Art Critic on Photography. *Amat. Phot.*, June 23, 1908, p. 625.

Technique—No Art Possible Without It. *Amat. Phot.*, July 7, 1908, p. 5.

Woodland Studies and Ever-set Shutters, *Phot.*, Aug. 11, 1908, p. 286.

Some Notes on Platinotype Printing. *Amat. Phot.*, Sept. 8, 1908, p. 223.

Personality, Technique v. Individuality. *Amat. Phot.*, Oct. 13, 1908, p. 350.

Personality in Photography—With a Word on Color. *Camera Work*, No. 25, Jan., 1909, p. 37–38.

The New Criticism. *Amat. Phot.*, July 27, 1909, p. 89.

Letter to Dixon Scott. *Amat. Phot.*, Aug. 17, 1909, p. 160.

Photographic Salon. *Amat. Phot.*, Sept. 21, 1909, p. 293.

Straight v. Controlled Prints. *Amat. Phot.*, Mar. 22, 1910, p. 303.

Controlled v. Straight Prints — and a Suggestion. *Amat. Phot.*, Apr. 19, 1910, p. 393.

The Soft Focus Lens and Sun Effects. *Amat. Phot.*, Sept. 13, 1910, p. 260.

Sunlight in Architectural Work. *Amat. Phot.*, Nov. 29, 1910, p. 532.

A Suggestion for a New Method of Judging. *Amat. Phot.*, Mar. 6, 1911, p. 221.

A Further Note on Judging at Photographic Exhibitions. *Amat. Phot.*, Mar. 27, 1911, p. 310.

Some Ancient Chinese Art. *Amat. Phot.*, July 3, 1911, p. 6.

Is It the Millenium? *Amat. Phot.*, Sept. 4, 1911, p. 229.

Street Exposures; a New Method of Dealing with an Old Subject. *Amat. Phot.*, Sept. 2, 1912, p. 235–36.

The Treatment of Over-Exposure on Ordinary Plates. *Amat. Phot.*, Oct. 7, 1912, p. 359.

Little-Known Corners of Well-Known Places: I — St. Bartholomew-the-Great, Smithfield. *Amat. Phot.*, Oct. 28, 1912, p. 434.

Contrasts in Durham. *Phot.*, Nov. 19, 1912, p. 424–25.

The Double Coated Plate. *Brit. Jour. Phot.*, Jan. 14, 1916, p. 25.

Mr. Coburn's Experiment. *Brit. Jour. Phot.*, Feb. 23, 1917, p. 102; Mar. 9, 1917, p. 126; Mar. 23, 1917, p. 155. Three letters.

CHRONOLOGY

1853 June 26. Born.

1883 Meets George Smith, proprietor of The Sciopticon Company, who makes slides from his negatives.

1887 Receives medal from Photographic Society of London for photomicrograph exhibit.

1889 Meets Aubrey Beardsley while professionally in business as bookseller.

1890 Shows first cathedral photographs at Photographic Society's annual exhibition.

1892 Gets Aubrey Beardsley his first artistic assignment: illustrating *Le Morte d'Arthur* for J. M. Dent & Co.

1897 The Architectural Club of Boston, Mass., exhibits 120 of his photographs.

1898 Retires from bookselling.

1900 One-man exhibition, Royal Photographic Society, London. Elected Fellow of the Linked Ring. Marries.

1902 Designs and hangs The Photographic Salon of the Linked Ring.

1903 One-man exhibition in the Boston, Mass., studio of F. Holland Day. Writes controversial article "Imitation: Is It Necessary or Worth While?" for *The Amateur Photographer*, June 11. Hangs The Photographic Salon. Evans issue of *Camera Work* (No. 4), with appreciations by Alfred Stieglitz and George Bernard Shaw.

1904 Important series of six articles on architectural photography published in *The Amateur Photographer*, Apr. 7 through May 12. Hangs The Photographic Salon. One-man exhibition at The Camera Club, London; plays Pianola at opening.

1905 Becomes a professional photographer on accepting roving assignment from *Country Life* magazine. Hangs The Photographic Salon for last time.

1906 Exhibits at Little Galleries of the Photo-Secession, New York, with J. Craig Annan and David Octavius Hill. In France from July to late September photographing French chateaux for *Country Life*; in his absence from London A. L. Coburn hangs The Photographic Salon.

1907 With G. B. Shaw counterattacks photographer Robert Demachy's criticism of pure photography as non-art. Travels in France.

1908 Arranges exhibition of good and bad mounting at Royal Photographic Society; gives lecture-demonstration at opening. The Photographic Salon allegedly dominated by Steichen and Coburn, both members of the Selecting Committee and installers of the exhibition. Evans represented by only one print. Indignant, he joins "Salon des Refusés."

1909 Contributes photographs to Memorial Edition of George Meredith's literary works. Judges The Photographic Salon. Virtual death of Linked Ring, with resignation of Stieglitz, Steichen, Coburn and other American members.

1910 Joins The London Salon Club, successor to the Linked Ring. 11 of his prints selected by Stieglitz for the International Exhibition of Pictorial Photography at the Albright Art Gallery, Buffalo, N. Y., organized by The Photo-Secession.

1911 Photographs Westminster Cathedral, London. Gives Pianola concert at Camera Club; introduced by G. B. Shaw.

1912 Privately publishes platinotype enlarged copies of Blake's illustrations to Vergil.

1913 One-man exhibition, "The A.P. Little Gallery," London. Privately publishes platinotype enlarged copies of Hans Holbein's *Dance of Death* woodcuts.

1914 Privately publishes a variorum edition of Edward FitzGerald's translation of the *Rubáiyát* of Omar Khayyam.

1916 Privately publishes a volume of line cuts from his photographic copies of Holbein's *Dance of Death* wood cuts.

1917 One-man exhibition, Hampshire House, London.

1919 Privately publishes *Grotesques by Aubrey Beardsley*, 12 facsimile platinotypes.

1922 One-man exhibition, Royal Photographic Society, London.

1928 Elected Honorary Fellow of the Royal Photographic Society.

1932 One-man exhibition, Hampshire House, London.

1933 One-man exhibition, Manchester Amateur Photographic Society.

1943, June 24. Dies, West Acton, London.

1944 Memorial exhibition, Royal Photographic Society, London.

1945 Memorial symposium, Royal Photographic Society.